Occam's Razor

The Mind-Machine

Occam's Razor

An Outside-In View of Contemporary Photography

by Bill Jay

Nazraeli Press

Contents

for Leilani

INTRODUCTION

Like amnesia victims after the shock of a horrendous accident, I have forgotten most of my schooldays, for similar reasons – the brain's blessed ability to expunge unpleasant memories. But I can vividly remember a few random events which, because of their rarity, have since become minor epiphanies. One of these brief moments which forever changed my life was when the class was instructed in the life of William of Occam (or Ockam or Ockham – there was no consistency of spelling in his days, a state to which present students are constantly aspiring.) Specifically, I was enthralled by a law which William propounded, called Occam's Razor.

Recently I had reason to refer to Occam's Razor in one of my seminars and was astounded that not a single student had heard of it. With unkind thoughts I directed them to look it up in a dictionary. I was both abashed and puzzled that the term did not appear in any of my American dictionaries, including *Webster's Unabridged*, which is so heavy it should be sold with casters.

There's an old saying in England: do not teach your grandmother to suck eggs. In other words, do not state what is already known. However, my classroom experience leads me to believe that a few words about William will not contradict the adage.

William was born in Occam, a town in the county of Surrey, England, around 1270. He was a Franciscan monk who, because of the heretical nature of his philosophies, led a stormy life, excommunicated and imprisoned by the then Pope but subsequently released by the Emperor of France. Then, even more than now, it was important to have friends in high places. But, to get to the point, many of William's ideas, so controversial in his own day, ring resoundingly true even now. For example, he argued that reality exists solely in individual things, and that universals

are merely abstract signs. How 'modern' can you get? This idea was important to William (and subsequent generations) because it led him to exclude questions that are 'abstract', such as the existence of God, from intellectual knowledge, referring them to faith alone. This should be rammed home to religious fanatics, like the Creationists, who are causing such havoc in American high schools ...

But here is the nub of the argument, which is called Occam's Razor, for reasons which escape me. William said that in all scientific and philosophical enquiry *variables should not be multiplied unnecessarily*. If that strikes you as less than sensational, let me elaborate. His rule requires two principles: a) the simplest of competing theories is to be preferred to the more complex, and b) explanations of unknown phenomena should be sought first in terms of known quantities. The fact that this idea was proposed some seven hundred years ago and still remains a guiding principle of all scientific and philosophical enquiry is nothing short of amazing. And that is how it struck my immature mind at the age of 16. This, for once in my studies, was a lesson I could live with, and by.

Indeed, Occam's Razor has been the guiding principle of my 'teachings' in photography for thirty years, whether as editor, writer, lecturer, educator or photographer. The point is: do not multiply the variables needlessly. Or, as graphic artists constantly admonish their students (and themselves): K.I.S.S. (Keep it Simple, Stupid!). Photography is, at heart, a very simple act, but exceedingly difficult to do well. It is a visual response to an emotional confrontation with the subject. The aim is to create a *picture* of this confrontation which can be divorced from the emotion which triggered the response. After that, anyone (including the photographer) can say anything about the image with varying degrees of relevance, because all subsequent meaning is supplied and applied by the viewer.

This stance has been called anti-intellectual. But it is not 'intellectual' to increase complexities needlessly, to express these irrelevancies in convoluted, impenetrable prose, or to pose as an expert in areas of limited experience. These are merely demonstrations of fuzzy thinking, bad writing and ignorance, respectively.

The pseudo-intellectual (a dominant species in photographic writing nowadays) makes the error of assuming that simplicity is the opposite of profundity, that if the prose is intelligible and easily assimilated then the issues are not worthy of deep thought. This is a fallacious assumption.

There's a wonderful story about one of the founders of quantum physics (I believe it was Rutherford) who, when confronted by a student wishing to expound on a new theory, would stop him and say: Go down to the local pub and try to explain your theory to the barmaid. When you begin to see a glimmer of interest in her eyes, *then* you can come back and explain it to me.

And what about the Sermon on the Mount? One of the most moving and profoundly inspirational texts ever uttered, yet all the words are so simple and direct. When Jesus had finished, Matthew recorded that "the people were astonished at his doctrine: for he taught them as one having authority, and not as the scribes."

I have endeavored to identify the issues of concern to young photographers, to talk about personal experiences, and to communicate ideas as simply, clearly and concisely as possible. My hope is that the words, like good photographs, will enter the readers through the bloodstream, taking time to reach the head. Above all, I have tried not to multiply the variables needlessly. Hence, the title of the book: *Occam's Razor.*

Perhaps the other part of the title, An *Outside-In View of Contemporary Photography,* also needs a few words of explanation. As I have already mentioned my schooldays, I can use another anecdote from the past as a springboard into a personal attitude towards the medium.

I first became enamored with photography as a teenager in England during the 1950s. In those days any personal involvement with photography might have been seen as a (marginally) acceptable hobby but it was highly inappropriate as a life-commitment, especially for someone who had received a 'privileged' education at a Grammar School for Boys.

There was a graduation ceremony at which the assembled school paid tribute to those who were moving 'outwards and upwards'. The headmaster read the roll-call of departing boys. "So and so has been accepted at Guy's Hospital where he will become a surgeon." Polite applause from

the assembled masses. Then: "So and so is joining the Missionary Society to be trained for work in Nigeria." Polite applause. The names continued, each boy destined for a life of service, reward and noble ambition. The headmaster reached my name on the list. "Jay . . . ," and here he paused, "has chosen to attend art college to study *photography*." There was a prolonged hush in the hall – and then the whole school burst out laughing.

Once my anger had subsided (it never entirely dissipated), I could understand, if not condone, the reluctance of the ignorant to accord photography the dignity and profundity which it deserved.

I was not deflected from a commitment to photography, in spite of such deterrents, because I had made, fortuitously, two related observations from the beginning of my interest in the camera and its images. And they have served to increasingly deepen my respect for the medium over the intervening thirty-plus years.

First, the most interesting, mentally-alert and well-balanced individuals I met during these early years were photographers. (They were all photojournalists in those days; fine-art photographers did not exist in England.) They were my role models. Of all the people I encountered, these photographers were human beings worth emulating. It occurred to me that if their only commonality was the camera through which they viewed the world, then this activity must hold the key to a more rewarding, highly-charged existence.

Second, I found that the surface of a photograph was slippery, literally but also metaphorically. It was impossible to study an image and stay there. The mind and heart kept 'sliding off', in all directions, provoking mental and emotional meanderings into geography, psychology, politics, biography, sociology, popular culture, art history, science, morality and a myriad of other connected fields until each picture seemed to resonate with the whole of human history. This was a personal discovery of eureka proportions.

To put it rather pompously, but I cannot find a more appropriate way of expressing it, photography became the most useful and accessible tool with which I could prise open an entry into a personal path towards enlightenment. I still believe that to be true. By comparison, therefore,

the early ridicule, born of ignorance of those who did not understand photography's potential power, was of miniscule significance.

I recount this personal background in order to provide the reader with a way to approach the following words, akin to switching on the runway lights as a guide to aircraft about to land. The fact, whether it is apparent or not, is that a singular compass-setting is behind all my activities in the medium of photography, whether image-making, writing, teaching, researching or whatever. That 'direction' presumes that photography is not an end result but a *means*. For me, photography's supreme value is that it is the most enjoyable, satisfying, efficient, convenient and complex method through which I am struggling with life's meaning: "to become *actually* what he deeply is *potentially*," to use Abraham Maslow's words. The search continues. These articles represent some of the by-products of photography's role in that search.

I hope these remarks will also serve to explain the book's subtitle: *An Outside-In View of Contemporary Photography.*

We live in a culture of ever-narrowing areas of specialization. It would be convenient, and more professionally rewarding, to follow the trend. Unfortunately I cannot resist photography's ubiquitous and multifaceted nature and its encroachment on every conceivable aspect of ... everything. In that sense, I am not an insider. I am more of a commentator/coach of the medium, as I remarked in one of these articles, yelling criticism at the missed opportunities and shouting encouragement to those who are making an effort.

So these words are particularly addressed to young photographers. And the message is a simple one: each photograph you make or view is like a pebble dropped into the pond of consciousness, its never-ending ripples lapping upon everything. Understand this about photography and life itself becomes richer and more meaningful. Four hundred years ago some anonymous person wrote the following lines (a Latin inscription on a German coin, 1589) which still ring true and serve as an appropriate credo:

Of what use are lens and light
To those who lack in mind and sight?

Finally, a few words about the illustrations.

The 'companion-book', *Cyanide & Spirits,* is illustrated with Victorian wood-engravings from photographic and other publications, which seemed inevitable for a collection of essays on 19th century photography. I wanted *Occam's Razor* to have a similar appearance and it therefore seemed appropriate to introduce each essay with a line illustration, like a wood-engraving, but with a contemporary theme, reflecting the issues of the accompanying text.

A young illustrator was found and commissioned, and supplied with the manuscript, as well as books and photographs for 'guidance'. And that was pretty much the last I saw of him. The deadline arrived and the artist (and drawings) were conspicuous by their absence. At a crisis-meeting with the publisher, the only alternatives seemed either to run the book without illustrations or to hire a new illustrator and delay publication for at least six months. Both options seemed equally unsatisfactory.

Serendipitously, we were in my office when I brought out a few of the montages I had made from Victorian wood-engravings. "Perfect," he said. "Use those." The idea filled me with trepidation. I had never shown them to anyone, let alone thought of publishing them. Reluctance gave way to enthusiasm.

The point I want to make is that none of the images was made, of course, with a particular article in mind, so they are not illustrations to the words which follow them, as was originally envisioned. They are independent objects. Still, I was intrigued to discover that many of them uncannily fit the 'feel' or spirit of the accompanying words. I hope they provide some pleasure and even food for thought while they serve to enliven the appearance of the book. The adventure is in the journey, not the destination.

Bill Jay
Summer 1992

Photography is the vehicle, not the destination

Photography as a spectator sport

KEEPING THE PHOTOGRAPH
AT ARM'S LENGTH

A Lecture on the Relationship of Life and Work

A few years ago I dated a psychologist. Briefly. She would throw me, unexpectedly, bizarre questions and then delight in analyzing them, detailing the negative aspects of my personality. We were watching American football on television when she asked: What position would *you* prefer to play. I should have known what was coming, but without thought I responded: I would prefer to be the commentator in the box, high above the field, watching and attempting to predict the patterns of play. Naturally this meant that I was anti-social, aloof, an egotist, a voyeur of life rather than a participant. Because she may have been right I was, naturally, even more irritated. Certainly, that is how I see my relationship to the medium of photography. Not so much as a participant, more of an enthusiastic commentator on the 'game'.

From this viewpoint, I would like to make a few general observations on the relationship between art and life in contemporary photography.

The crucial question is this: What relationship does a personal life have on an individual's photographs – and vice versa.

The answer, like a response in the *I Ching* to any of life's big problems, can be amazingly succinct: life and art should have *everything* to do with each other. In practice, as I view the medium of art photography, from my outsider position, art and life have very little connection.

In fact, I think this is the central problem in the medium of art photography at the present time.

Like all short responses to complex issues, more questions are raised than are answered, until they start bubbling into consciousness at an increasing rate, popping in the mind at alarming frequencies. Words like 'Art' and 'Life' tend to have this effect more than others. (Books don't

get written by photographers about words like 'sump oil' and 'hamburgers.')

So a few more words are necessary to explain more clearly what I mean by art and life being connected in a much more profound way than I observe occurring in contemporary photography (or any art).

First, a simple example.

While living in England, I would perform a double-act with David Hurn, a Magnum photographer. He was often asked to lecture at colleges but disliked speaking in public. So I would traipse along and 'interview' him in front of the audience. This for him, was a lot less stressful. One day, the students had prepared for our visit by mounting an exhibition of their work which we dutifully viewed before the performance. As the 'interview' progressed, students increasingly asked: But what about *our* work? Eventually, the question had to be answered. Hurn's answer was: They are incredibly boring. He said: When I look at a young photographer's images I expect to feel *jealous* because he or she has access to subjects, life-styles, people that are closed to me, because of my age and who I am. Where, he said, is an expression of *your* uniqueness as a human being? You have only photographed what I, and other professionals, could have, have already, photographed – and better!

It is a good point.

Students are taught, by implication, that their photographs must make reference to current stylistic trends, deal *meaningfully* with critical issues in the medium, refer self-reflexively with photography itself. Because that is what so-called significant photographers are doing. Life itself? Irrelevant.

A few years ago, a teaching position became vacant at the university with which I am associated. Forty applicants submitted work. *Fifteen* photographers, from all over the USA, submitted images of bushes, at night, lit by flash, in color! (Trends, nowadays, are so short-lived that this description could be used to identify the exact year – and even the time of year – when the applications and portfolios were submitted.) What magic suddenly made bushes so relevant to the lives of so many photographers simultaneously? Why was the burning desire to picture bushes so rapidly and simultaneously extinguished?

16

I am sure you can all think of similar short-lived trends: the urge to record the corners of nondescript rooms, garages and motel lobbies, for example. Or San Francisco's own 'Fabricated to be Photographed' mania.

All relevant to personal lives? I do not believe it.

In art photography personal lives have become irrelevant. Appearance of the image is all. Issues in the medium swell up randomly and arbitrarily, sweeping the tiny, insignificant world of academic image-making. Those who have been blown away in the first gusts, receive the attention of the medium and become 'known' for, oh so short a time, until the wind blows in a new name. And who is blown away first and thus receives attention? Those whose work is not-rooted, firmly planted in life's experiences. Hence we have an explanation why those who least deserve attention are often the quickest to receive it.

Am I recommending that photographers concentrate on the intimacies of their own lives, self-indulgently examine every bit of fluff in their own navels, thrust their cameras into every crevice of their, and their partner's, bodies? God forbid.

At least the sterile images of the formalists can be viewed with the bored indifference that their work deserves. The frontal intimacies of those who act as if they were the only individuals to experience emotional *angst* are as difficult to ignore as spoilt brats, clamoring for attention while the parents are attempting to communicate.

One of my friends was determined to photograph Real Life. He decided to photograph his wife and kids in all moods, not just the nice moments. His wife could not conduct her toilet without having his camera thrust at her; in the midst of a domestic squabble the camera entered the fray; the camera accompanied them to bed. No wonder the wife divorced him.

A colleague told me the following story, with approval, of a photographer's commitment. He was asleep in bed, with his wife, when the telephone rang. He answered it, listened for a while, and asked the caller to hold on. He then fetched his camera, focused on his wife, and woke her to tell her that the call was for her. When she picked up the telephone she learned that her mother had just died, while the husband was photographing her reactions.

That is not *caring*. That is active, out-and-out, callous, cold-hearted aggression.

Apart from a lack of manners, taste and common humanity, these photographers display an abysmal ignorance of life: no one is interested in the sordidness of their petty lives.

Having written on both ends of the formalist/intimacy spectrum, I owe it to you to state what I think is meant by the ideal relationship between life and work/work and life.

A photograph is the end product of someone caring about something 'out there'. The best photographs exude this caring attitude in a manner which is not definable but which is very evident.

Lewis Hine, for example, was not interested in promoting himself as an artist-photographer but he did care deeply about the plight of children who were employed in dangerous environments under conditions of slave labor. He began working for the Child Labor Committee in 1907 and his photographs, badly reproduced in such tiny images that they often seemed swamped by text, were published in *The American Child*. He recognized that words would tell the story, but that his photographs could make the story emotional and dramatically real. He cared, and it showed.

But this caring for the subject is not the prerogative of such emotionally charged themes as child labor. Stephen Dalton obviously has a passion for, and deep knowledge of, insects. His technically amazing, and aesthetically beautiful, images of insects ooze a love for bugs even to those who have an aversion to the little beasts themselves.

Other examples would be superfluous because *all* good photographers have a deep commitment to, and involvement with, their subjects, and through photography they are communicating their understanding and passion to others. If nothing out there is utterly absorbing then a good photographer cannot exist. It's like trying to be a scuba diver in the midst of the Mohave desert. If the photographer is communicating a personal passion for something, anything, through the pictures then the images are also revealing, incidentally, a great deal about the photographer as well as the subject. His or her attitude to life is evident.

On a simple level this fact is explicable merely because a photographer's choice of subject matter can be revealing of personality as well as interests. At a deeper level, the issue becomes more profound. The more intensely the photographer struggles to place emphasis on subject matter so, paradoxically, the photographer reveals a personal attitude to life itself. This is never revealed in a single photograph. However, a body of work by a photographer begins to reflect back to the viewer the author's relationship not only to the subject but also to a unique life-attitude.

This cannot be injected into a photograph by intent. Style is not like a filter which when placed over the lens will affect the image. Too many young photographers shoot a sleeping drunk in a doorway to show they care; in actuality it usually shows the opposite. As one character remarked disparagingly: You can tell the price of a photographer's equipment by the number of rags in the picture. When I walk through the forest at night, the track emerges from the darkness by *not* looking for it. A unique style emerges in photography by ignoring it, concentrating on the subject, and allowing care, passion and knowledge to bubble to the surface through a lot of hard work over a long period of time.

That is why the best photographs are truly reflective of the photographers. The pictures become extensions of the person and it is evident that a personal style has emerged, which cannot be confused with the works of any other photographer. This is not difficult to understand; it is clearly evident in the style of writers, poets or musicians. Style in photography operates in exactly the same way, in spite of this medium being more closely identified with reality.

There is no paradox in the close link between a life-attitude and a discussion of style. This was deliberate because in the same way that the subject matter reflects areas of interest so a photographer's style reflects his attitudes. For example, Don McCullin is probably the greatest war photographer the medium has yet known. His subject matter is depressing to put it mildly. Starving refugees, bombed children, mutilated civilians, dying soldiers, terror-struck families and decaying corpses seem as though they should be extremely depressing images by a masochistic voyeur. Yet

... look at a large number of McCullin's horrific images and another deeper impression emerges to counteract the first shock reaction. The photographs, *en masse,* exude a dignity, pride of spirit and commitment to human values under the extreme test of their endurance. They are inspiring, and in spite of the subject matter, elevate the spirits and reaffirm the universal hopes of humanity. And that is the mark of a great photographer.

Therefore there is no paradox between a photographer placing emphasis on subject matter yet by dint of commitment and understanding revealing a personal life-attitude. All great photographs are made at this interface between reality and subjective response. They are personal and objective simultaneously.

So, the question of most relevance to all young photographers is this: What are you interested in, what excites, intrigues, moves, fascinates and energizes you? What could cause you to wake up with a sense of excitement about the coming day?

More often than not, the student will not, cannot, respond. The very notion seems preposterous. Formal education (in photography) has a lot to answer for. We have legitimized, sanitized, academized, the medium until we are left with issues not substance, critical stances not action, we have encouraged the mimicking of already dead images, like 19th century painters who spent years copying Greek statuary.

The umbilical cord between life and art has been severed. And academic art photography is dying. I'm in favor of euthanasia to put the patient out of its miserable existence.

But that is such a negative note on which to end. Instead, I would like to paraphrase and quote from the truest, most beautiful, relevant and humbling essay ever written about the relationship between life and art. It is Ingmar Bergman's introduction to his film script of *The Seventh Seal,* 1968.

Bergman tells the story of how the old cathedral of Chartres was struck by lightning and burned to the ground. The call for help echoed across nations. Then thousands upon thousands of people congregated on the site, each bringing whatever talent he or she possessed. They labored until

20

the new cathedral was complete – stonemasons, master-builders, carpent-
ers, priests, laborers, cooks, clowns and noblemen. They all remained
anonymous and no one knows to this day the names of those who rebuilt
Chartres.

Bergman comments: "Regardless of my own beliefs and my own
doubts, which are unimportant in this connection, it is my opinion that
art lost its basic creative drive the moment it was separated from worship
... In former days the artist remained unknown and his work was to the
glory of God. He lived and died without being more or less important
than other artisans ..."

In those days, the ability to create was a gift. "In such a world," says
Bergman, "flourished invulnerable assurance and natural humility." By
contrast, Bergman berates today's individual, "the greatest bane of artistic
creation" whose "smallest wound or pain of the ego is examined under
a microscope as if it were of eternal importance."

"Thus if I am asked what I would like the general purpose of my films
to be," wrote Bergman, "I would reply that I want to be one of the artists
in the cathedral on the great plain. I want to make a dragon's head, an
angel, a devil – or perhaps a saint – out of stone. It does not matter which;
it is the sense of satisfaction that counts. Regardless of whether I believe
or not, whether I am a Christian or not, I would play my part in the
collective building of the cathedral."

The price of inspiration

THE THING ITSELF

The Fundamental Principle of Photography

For nearly thirty years I have been deeply involved in the medium of photography; for most of that time I have directed my lectures and writings at young(er) photographers.

Hopefully my own attitudes to the medium will continue to evolve; certainly, they have undergone continuous change. In looking back at the last three decades, however, I have been aware that one fundamental attitude has remained at the core of all my experiences in the medium. It is this 'frame of reference' which I would like to share with you in a single article.

I am not claiming that this principle of photography is radical, different or new. On the contrary. I believe that it is familiar and basic – which means that it deserves and demands constant repetition, in an age when principles are often impugned, as if they no longer held relevance.

But like all fixed rules, it must also be accompanied by flexible strategies, allowing for individual images of insight and brilliance which, seemingly, ignore the principle. But it is there, and no less crucial for being hidden, like the foundations of a building.

Perhaps the most obvious, and therefore the most contentious, issue of photography is the medium's inseparable relationship to The Thing Itself. Photography performs one function supremely well; it shows what something or somebody looked like, under a particular set of conditions at a particular moment in time. This specificity has been, and remains, photography's boon as well as its bane.

It was not by chance that photography was born in the early 19th century when a deterministic spirit was fueling the Victorian's fanaticism for facts. The camera, along with the microscope and the telescope, became one of the primary instruments for investigating the details of reality. Deeply and strongly rooted in subject matter, the medium has had an

uneasy and tenuous alliance with authorship since its introduction. Therefore, what a photograph *depicts* has generally taken precedence over what a photograph means.

The advantage inherent in this notion is that photography has become an increasingly useful tool in our society for the transmission of information about every conceivable aspect of life.

The 'disadvantage' is that while a photograph is directing attention to its subject, it is de-emphasizing the role of the individual who made it. Indeed, in the vast majority of photographs, even those of extraordinary impact in our lives, we have no knowledge of, or interest in, the author. Attempting to make individualized (artistic) photographs in this environment is a bit like discussing metaphysics at a football stadium during the Super Bowl. This does not mean that the attempt is without value; it may indeed influence your neighbor. But it does mean that the chances of being recognized by the public at large is less than likely.

The act of photography is a similarly private act, unlikely to be rewarded or even noticed by society in general. The young photographer must come to terms with this fact. A photographer with artistic aspirations has a very small audience – one which is increasingly congregating within the faculty at colleges and universities. These institutions have replaced the church and the princes as the major patrons of the arts in our society. Indeed, about the only way it is possible to earn a healthy living from being a photographic artist is to become an academic. And this is the primary value in attending graduate school – to earn the qualifications necessary to become employed as a college teacher/art photographer. In this role, the artist has the freedom to expand his or her creative potential.

I have mentioned the arts in academia in order to throw an oblique light onto a previous assertion. It is this: most of the Great Names used in academia, for the inspiration and edification of students, would not be eligible for graduate studies, let alone as faculty members. Most of them were professional photographers, earning their livings on assignment in journalism, industry, fashion, medicine, and a host of other photographic applications. My point is that great (even artistic) photography is not a function of environment or a prerogative of academia.

A corollary of this point is that you cannot be a photographer by aspiring to be one, or by learning everything there is to be known about photography. Photographers produce photographs. And many of them. Like every other skill, photography is learned by continuous and dedicated practise.

One well known photographer came to stay at my home and shocked the local photo-dealer by ordering 1,000 cassettes of 35mm film. I assure you that every frame had been exposed within one year. That equals an average of 100 frames per day, seven days a week. Another photographer friend shoots a roll of film *every* day "even when not photographing" because, he says, "it is essential to keep the eye in training." It is true that these two examples are of particular types of photographers but nonetheless the principle remains: you do not become good at anything unless you do it earnestly, regularly, and, yes, professionally.

This truth inexorably leads to a single, but usually ignored, matter of fact: in order to photograph with any degree of continuous passion, you must have a fascination for the subject, otherwise you cannot sustain an interest in the act of creation for a long enough period of time in which to make any insightful or original statement about it. In spite of its seemingly heretical slant (in this day and age) *what* you photograph is usually more important than *how* your photograph it.

The photographer is, first and foremost, a selector of subjects. The photographer makes a conscious choice from the myriad of possible subjects in the world and states: I find *this* interesting, significant, beautiful or of value. The photographer walks through life pointing at people and objects; the aimed camera shouts, "Look at that!" The photographer produces pictures in order that his or her interest in a subject can be communicated to others. Each time a viewer looks at a print, the photographer is saying, "I found this subject to be more interesting or significant than thousands of other objects I could have captured; I want you to appreciate it, too."

This immediate emotional or intellectual response to the subject matter is at the core of photography. Its periphery is the photographer's manipulation of framing, focus, exposure, lighting, and all the other variables, in

order that a bland record is invested with depth through the production of an intriguing image.

I have stressed the importance of subject matter because it is the fundamental principle of photography – and, paradoxically, the least discussed area of the medium, especially to young photographers. I can understand this reluctance. We all have grandiose aspirations for, and expectations from, photographs and this leads to a plethora of concepts, as well as aesthetic and critical theories which, when heaped on the back of photography, bring the medium to its knees, not in homage but in defeat. The fact of the matter is that photography cannot bear the intellectual weight with which it is fashionable to burden it. Photography is not an intellectual game, but an emotional response to charged living.

After a critical essay of mine appeared in print, Ralph Steiner would often write me a funny, provocative and stimulating letter. But he would end with the words: "But you *still* have not told me in which direction to point the camera – and this is what matters." And he is right.

However, giving specific advice on what to photograph would not be appreciated even if it was possible. The answer is provided by a question: What are you *really* interested in? In other words: What is it that can sustain your enthusiasm for a long time? I advise young photographers to be overly pragmatic in answering such questions. First, list all those subjects which fascinate you – without regard to photography, *i.e.* what would you be doing if there was no such thing as a camera. After the list is made, you then start cutting it down. Eliminate those subjects which are not particularly visual. For example, existential philosophy can be deleted. Then cut out those subjects which are impractical, for one reason or another. For example, I have always been fascinated by Patagonia but, as I live in Arizona, it is not a subject which I can shoot at available hours and weekends. The subject must not only be practical but also accessible. Also eliminate those subjects about which you are ignorant, at least until you have conducted a good deal of research into the issue. For example, you are not making any statement about urban poverty by wandering back streets and grabbing shots of derelicts in doorways. That's exploitation not exploration.

Continue similar reductions in your list of interests until two or three subjects remain, all of which a.) fire your enthusiasm b.) lend themselves to images, as opposed to words and c.) are continuously accessible.

Let me give you an example. As a teacher I encounter a great number of photographic students who are active in college life, naturally emotional about many aspects of education, and who spend the greater part of their waking life on campus. But in the past 15 years, and over 1,000 students later, I have *never* seen a photographic project based on what it is like to be a college student. In fact, it is rare indeed to see a photographic student carrying a camera.

Instead, they select subjects about which they *assume* their professors (or the art community at large) expect from a photographer and wonder why they cannot sustain any interest in making pictures. Photography has become a grade-producing chore and the thrill of visually confronting the world has lost its sharp edge of discovery, the original reason, perhaps, why the student became a photographer.

But back to the list ... with some hesitancy, I admit, I would recommend one further elimination process. It is this. When you have two or three visually possible and accessible subjects, *all of which interest you equally,* it is no compromise to select the subject which *others* are more interested in viewing. The state of being human dictates that some things are visually more interesting than others.

As a lecturer, I am well aware that it is difficult to transmit information to a disinterested, bored audience. You must engage and hold the audience's attention before the content can flow. It is the same with images. Just be aware that some subjects are more accessible and interesting to the layperson than others – and it is deliberately perverse to ignore this consideration. There is a very fine line between pandering to popular appeal and a respectful consideration of viewer's interests, and only the integrity of the photographer will hold the balance.

All this talk about emphasizing subject matter might indicate that I am only advocating a strict, straight recording of objects. But this is not so. I have been talking about *starting points*. I do believe that the narrower and more clearly defined the subject matter, the more scope there is for

a continuing evolution of complexity and, hence, the greater the latitude for personal interpretation. An analogy might help to explain my point.

I have recently re-landscaped my front yard and now need to plant trees. I could have an 'instant' tree by collecting an assortment of trunks, branches, twigs and leaves and assembling the parts. But the tree would be dead. The starting point for a living, growing tree is a seed or a sapling. Then by careful nurturing, and a good deal of patience, a tree will grow – often into a form which could not have been foreseen.

It is the same with a body of work, of any merit, in photography. The greatest scope for deep-rooted, organic growth begins with the most simple premise.

The alternative is a frantic grasping for instant gratification which merely leads to works displaying visual pyrotechnics but of dubious depth and resonance. This is the fallacy of form. Young photographers are often pressured into an emphasis on individual style, a search for distinction, a quest for newness and differentness. Yet the truth of the matter is that a unique style is a by-product of visual exploration, not its goal. Personal vision only comes from not aiming for it. In dim light, objects emerge from the gloom when not looking at them. It is the same with style; paradoxically, it is a natural, inevitable result of emphasizing subject, not self.

And this principle brings up an equally important correlation between subject and self. If it is perceived to be important that the self should be ultimately revealed, the question arises: What is the nature of this 'self'? If the self is shallow, narrow and inconsequential, so will be the resultant photographs. It seems an extraordinary presumption that *every* photographer has a depth of character which demands revelation!

Inevitably, most photographers would do the world a favor by diminishing, not augmenting, the role of self and, as much as possible, emphasizing subject alone. This is not meant to be facetious. Such photographers would be members of an august group – the majority of photographers throughout the medium's history, most of whom remain unknown as personalities. However, the emphasis today is on a cult of personality and individualism, and I presume that the majority of young

photographers who encounter these words are anxious to assert self. Like all noble aims, however, it is not achieved without varying degrees of responsibility and hard work. The young photographer must develop a photographic conscience.

What I mean by this term is this: if the subject of the photograph is the vehicle for profounder issues, then it is the photographer's responsibility to think and feel more deeply about those issues. That sounds self-evident. But how is it achieved? By a seriousness of spirit. And how is that achieved? By engaging in a quest for self-knowledge which invests the act of *living* with greater energy and commitment. I am well aware that this sounds very nebulous. You cannot wake up one morning and assert: Today I will be aware and more alive. It starts like self-expression, with a concentration on focus – on the subject matter. It presumes that the subject deserves not only looking, but also thinking, reading, writing, talking as well as photographing – earnestly and energetically.

I once watched a television interview with a great violinist. The interviewer asked him to describe a typical day. The musician said he read scores over breakfast, then composed music in the morning, thought about music during a walk, practised the violin in the afternoon, played in a concert in the evening, met with musician friends to play together, then went to bed dreaming of the violin. The interviewer was aghast – it seemed such a narrow life. "Yes," said the violinist, "initially my life was becoming narrower and narrower in focus. But then something extraordinary happened. It is as though my music passed through the tiny hole in an hour glass and it has since become broader and broader. Now my music is making connections with every aspect of life."

In this sense photographers are photographers one hundred per cent of the time, even when washing dishes. The ultimate aim is an oscillation between self and subject with the image being a physical manifestation of this super-charged interface between the spirit and the world.

It demands reiteration: this conscience of the photographer is not learned, not appropriated, not discovered, not acquired quickly or without effort. It is a function of the photographer's life. And it begins with an intense examination of The Thing Itself.

If this presumes too much, I make no apologies. The young photographer, unwilling to develop such a conscience, can always move on to some other activity, without failure or shame, or join the army of hobbyists who derive great pleasure from their images, or employ the medium in its honorable role of documentation without artistic presumption.

My concern is with those who engage in artistic posturing and shallow assumptions, using photography as if it was a clever trick and employing stylistic devices in a sleight of hand which deceives the eye.

An earnest and honest appreciation of subject matter is the genesis of a clearer, deeper vision. Photography is rooted in The Thing Itself.

Reasons for agitation in the darkroom.

THRESHOLD – The Disturbing Image

A Survivalist Guide to Contemporary Photography

Have you ever seen someone extinguish a cigarette in the remains of food? Now *that* is disturbing. It is unsettling, disgusting, offensive, sickening, shocking and downright repulsive. It is also fascinating, especially when accompanied by a sizzle followed by a whiff of burnt cabbage.

Yet this act, I presume, is not disturbing to the smoker. It is the same in photography. The image-maker is rarely disturbed by the production of a picture which disturbs its viewers. I do not know what that means except it serves to clear up an important point right from the start: photographers of disturbing pictures are not necessarily unkind, insensitive, callous, unfeeling or uncaring individuals whose willful perversion is to shock and cause discomfort to others – although they could be.

Therefore, this introduction to the disturbing image does not concern itself with the photographers' motives or lapses in good taste. It is concerned with the images themselves and some of the reasons why they gut-shoot us, no matter how sophisticated we might be as viewers of photographs.

We can begin by making some distinctions in definition.

First, there are two main definitions of the word 'disturbing' which could be applicable in this context. 1.) The image pushes the viewer to the limit of emotional acceptance. It produces anger, shame, shock and pain in degrees that eventually cause rejection. This is the definition which is usually associated with disturbing images, and the one which will be given greater attention in the following words. 2.) The image disturbs in the sense that it rocks the *status quo* and tends to break up the settled order of things. How this definition applies to photography will be discussed, briefly, at the end of the article.

We must also make a clear distinction within the first definition. (Here we go again.) Images which disturb in that emotionally-shocking sense

can be divided into two groups: a.) Those which are *generally* conceded to be shocking and b.) those which are *personally* shocking.

1a.
Disturbing the Evolutionary Urge

When we first think of 'disturbing' images, it is a fair bet that the images which immediately spring to mind feature abnormality (mental or physical), sex or violence. These themes represent the tripod on which visual shock is based. And that is understandable, even right and proper. The reason is this: *The most disturbing subjects threaten our survival as a species.* The fearsome triumvirate has been so deeply, genetically encoded, over half a million years of evolution, that we cannot escape its devastating implications. As with all animal species, the supreme, unwavering, incessant clamor of our instincts is to survive. Any threat to that urge will fill us with panic, even if that threat is only subtly sensed in the mild reflection of the photographic image. We are all programmed to respond to stimuli and the most extreme reaction occurs when the threat, even imagined, is to the continuation of the human race. If entropy is the universal law for all inanimate objects, then its opposite is the rule for all living things. The evolutionary urge is to procreate, grow increasingly complex, adapt to the environment, and, in the case of humans, expand consciousness.

Abnormalities threaten our chances of finding a mate and contributing to the hardiness and survival fitness of the race; sex, freed from procreation, offends a primitive biological need; violence reminds us of our vulnerability and impending death, and, by extension, the extinction of our species as a whole.

It sounds far-fetched and remote from the images on flat sheets of paper. I, too, would have thought so. But the more I pondered the disturbing nature of so many images, it seemed the reason grew ever clearer. All those images, which were *generally* considered to be disturbing, were at odds with our evolutionary urges.

34

You do not need to be a Darwinian or an advocate of behaviorist psychology to see the beauty, or the sordidness, of this argument.

The beauty is that we no longer have to come to terms with disturbing images; our reactions of shock, disgust and rejection are natural, understandable and to be applauded. Our repulsion is a healthy, vigorous form of self-defense. Conversely, an embrace of this imagery is a prelude to a dance with death.

The sordidness of the argument, however, is that we all share the same buttons which can be pushed in order to elicit a predetermined emotional reaction, ranging from a vague uneasiness to active rage. The exploiters among us have discovered our buttons and push them with glee, voyeuristically congratulating themselves as we squirm to order.

Sex and violence, it hardly needs reminding, are the staple ingredients of practically all novels, movies and television series and specials. The interesting question here is why the majority of viewers are not only willing to submit themselves to such predictable lust and carnage but actively seek it, like lemmings who cannot wait for the looming cliff-edge of extinction. The answer, I think, is two-fold. We do not have much choice. Ours is a capitalist, consumer-oriented society, for good and ill. And anxiety sells. An anxious, disturbed, unsettled viewer or reader makes for a good consumer. Through disturbing images we are being manipulated.

The other reason why we actively embrace emotional disturbance is a bit more philosophical; the closer we can approach a survival-threatening situation, even vicariously through an image, without actually succumbing, then the more alive we feel. Photography (and film) allows us to approach the cliff-edge without physical risk. We can play Russian roulette with a fictional silver bullet.

These preliminary ideas deserve a great deal more words, although they will serve to open the debate. *Tempus*, however, *fugit,* and we must press on.

1b.
Disturbing a Personal Angst

Even if the preceding argument is tentatively accepted as a working hypothesis, it does not explain why some individuals will be gravely (an appropriate word) disturbed by specific images while others will be left immune. It also fails to explain the shift in what-is-disturbing over the passage of time or to explain the image which would be regarded as generally disturbing in one culture but neutral in another.

The generalized argument should be considered as the background noise, the hum of traffic, against and within which individual songs are sung. Viewers reacting to disturbing images might not be, seldom are, consciously aware of the issues of survival but that does not mean the 'noise' does not exist, intermingling with and distorting the personal voices. When we begin to locate and identify personal reactions to disturbing images we find, yes, a disturbing fact.

The images which disturb particular individuals are rarely located in a fixed band of the photographic spectrum or associated with a particular subject matter or identified by the identical reaction from a similar group of viewers. When we move from the general to the specific a new set of factors *seems* to emerge. In the personal category we must abandon a fixed root-cause of the disturbance and think of disturbing images as a multitude of pulsing circles, moving randomly and horizontally at various speeds across the whole arena of photographic expression, as well as vertically throughout the culture, while shifting in size and location as time passes. There is no single static circle to locate, fix in position, and measure.

Personal responses are exactly that: personal. To indicate what I mean, it is necessary for me to become personal on occasion. Not that my reactions are particularly interesting, and they are certainly not exemplary, but because they are immediately accessible they will, I hope, act as examples of the factors which alter the degree of disturbance, with reference to specific images.

One photograph which constantly emerges in any discussion of disturbing images is *'Chicken Entrails'*, 1939, by Frederick Sommer. I would

36

agree that it is a powerful, beautiful photograph – but it is not, to me, in the least bit *disturbing,* and for a logical reason. The subject is so familiar that it holds no special strangeness. I paid my way through school and art college by working in a slaughter house/butcher shop; I hunt and am surrounded by neighbors who hunt, and the act of gutting and skinning is merely a chore; I keep chickens for meat as well as eggs and chicken entrails are a familiar sight, and always have been. It is a recurring surprise when urban visitors to my cabin in the woods are repulsed by the sight of blood and guts. I am not making judgments or apologizing; merely indicating that it is unlikely that we will be disturbed by an image of a *familiar* subject. The disturbing image is inevitably of an exotic, unusual scene, removed from our day-to-day experience.

It reminds me of a photographer friend who, on a visit to India, pictured a washed-up bloated corpse being ravaged by wild dogs, with the pristine beauty of the Taj Mahal in the background. The image was definitely disturbing. Although it was widely published in the West, no Indian journal would use it – because it was such a familiar, prosaic scene, of no interest to anyone.

An important point should be injected into the discussion at this stage. This journal's readers are particularly prone to being disturbed by a wide range of images. Educated, comparatively affluent, middle-class Americans have become so comfortable, thank God, in their ascendancy over hand-to-mouth survival that they are more easily disturbed and shocked by the raw crudity of life outside fortress USA, or even within it, if the forces of disaster threaten their prosperity and well-being. It is as well to bear in mind that the vast majority of images which we find disturbing would have not the slightest emotional appeal to the vast majority of people in the rest of the world. But that again, is another issue. Back to the *personal* reasons why some images disturb more than others. Individual experiences not only anesthetize us to certain images but also highly sensitize us to others.

For a publishing project I wanted to reproduce a series of photographs by Duane Michals called *'Homage to Balthus',* in which a woman undresses while a passive, seated man watches. It is not a salacious group of images

by any stretch of the imagination. However the publisher's reaction was extreme and adamant. Under no circumstances would those images appear in any publication with which he was associated. A curious, but in the light of his explanation, a most reasonable reaction. These images were particularly disturbing to the publisher because he was a Hungarian Jew and associated Michals' images with the forcing of Jewish girls into prostitution by the Nazis. The associated was so strong that he could not even bear to look at them, although clearly Duane Michals was not intending to so disturb a viewer in this particular way.

We all have trained Dobermanns in our heads, waiting to savage us if our thoughts step out of line. Sometimes we are not aware of the original 'order' which provoked the savaging. While I was editing *Creative Camera* I received a furious letter from a woman who cancelled her subscription because I had dared to publish a blatantly pornographic image which was disgusting in the extreme. Puzzled, I was anxious to ascertain which particular image had provoked such outrage. It was *'Two Shells'*, 1927, by Edward Weston.

This example only goes to show that almost any photograph could be disturbing to someone, at some time. (The irony is that Weston would not have been surprised by the woman's reaction because several friends had already commented that the image "stirred up all my innermost feelings so that I felt a physical pain", and, "they contain ... the morbidity of a sophisticated, distorted mind", and yet another friend used the specific word "disturbing" to describe the print, and that he felt "weak at the knees.")

Edward Weston's photograph began its life as a disturbing image, was canonized, sanitized and legitimatized as Art, and found a later viewer, on a different continent, who was again profoundly disturbed by it.

And sex is always a predictable source of image disturbance. It is such a deeply-rooted animalistic urge modified by an infinite number of personal experiences and cultural training, not to mention manipulations, that every individual possesses raw wounds just waiting for the salt of certain imagery. To illustrate my meaning, consider the fact that John Ruskin could never consummate his marriage to Effie, once he had seen

her in the nude. Ruskin had seen plenty of nudes in his life – but only the idealized Greek statuary which unmarried artists were encouraged to copy. And what was the distinguishing factor of these marble heroines? They were devoid of pubic hair. When Ruskin noticed that Effie was naturally hirsute, it so offended his idealized sensitivity that he was profoundly revolted. The hairy animal was lurking within the pure goddess.

We all harbor personal fears of a like nature which find expression in the imagery of others. We also search out the images which disturb us, in the same way that we obsessively pick at a scab. One of the most profoundly disturbing photographs I have ever seen was projected by A. D. Coleman during a lecture on the 'Grotesque in Photography'. It depicted a beautiful young woman, eyes closed, naked, languorously and vulnerably stretching as if in post-coitus satisfaction. How utterly desirable! Then, with slight disturbance, I noticed the long line of stitches down her abdomen – and Coleman explained that she was a cadaver, photographed by Jeffery Silverthorne after an autopsy. I was, indeed, disturbed – as much for my secret wish to make love to a corpse as for the pity of a young life prematurely ended and for the unfamiliar sight of a death stripped of its newspaper voyeurism.

What is particularly significant about this example, however, is the importance of Coleman's *explanation*. Words were required before the disturbance of the image was received with full power. We constantly need reminding that photographs are not narrative in function, and when asked to perform in this role they need words. In fact an important point must be stressed: The source of much disturbance in photography is created by the words which accompany the image – with the image making the words up-close, real and actual.

A good example is the innocuous still-life taken by Shomei Tomatsu and reproduced in Max Kozloff's *Photography and Fascination* (p. 174). On first encounter it appears to be an artfully contrived 'study' (with, I might add, striking visual similarities to *'Chicken Entrails'*.) The explanation is that it is a prosaic record of a beer bottle distorted by the searing heat of the atomic explosion over Hiroshima. Only with the release of that specific information does the image become profoundly disturbing.

And this point brings up another factor in the causes of image distur-
bance: symbolism. Every image causes our brains to leap alive, with syn-
apses clicking, along infinitely complex circuits. When the end of the
electron trail is a latent memory then the result is emotional disturbance.
I once walked past a doll factory outside of which was a table of spare
limbs. As I bent over the doll parts, fiddling with exposure and framing,
a frail old man stopped and wheezed over my neck. When the (bad)
picture had been taken, he tapped me on the shoulder, explained he was
a World War I veteran, pointed to the heap of limbs and said "That's
what it was like at Verdun!"

Dolls as symbols of people, of course, are commonly used emotional
triggers within the traditions of photography, and no less effective for
that, as witnessed by the works of Vilem Kriz, Hans Bellmer and many
others.

Personal responses to images are so variable that no explanation will
satisfy our desire for a conclusion. The temptation is to relate case after
case after case in the hope that sheer quantity will yield The Answer.
Why, for example, did a .45 pistol-toting viewer kidnap a 13 year-old-boy
and demand, as ransom, the removal of four prints by Les Krims from
the walls of the Memphis Academy of Arts in March 1971? The images
were so disturbing that they drove a man to crime, and caused the pho-
tographer to fear for his own life.

Most of us do not respond to such imagery with action, but by mental
withdrawal, with emotions more akin to embarrassment than anger. I feel
this way when confronted by the recent rash of photo-autobiographies,
which reveal the most intimate details of the photographer's relationships
with family, friends and lovers and their own bodies. I resent being
manipulated into an uneasy sense of intrusion, of callously voyeuristic
complicity. How dare they make me feel so uncomfortable!

But few of my colleagues seem to share my distaste for a stranger's
intimacies, so I am forced into accepting that my reaction is *personal* and
leads me into asking myself personal questions about the source of my
disturbance. In that sense all disturbing images *can* be therapeutic and
thereby valuable.

There is no doubt that deliberately disturbing images are in the ascendancy right now. It is inevitable; a reverse swing of the pendulum after a few years of New Topographic style objectivity, of cool, non-involved, unemotional, author-less images. Predictably, the swing is towards the opposite: feverishly hot subject matter charged with dervish emotionalism by an idiosyncratic author.

Where will this lead and are there limits to acceptable subject matter? Where are the boundaries? The assumption in such questions is that imagery is pushing outwards and that which is acceptable today would not have been tolerated yesterday. I do not subscribe to this theory. Shocking, disturbing imagery merely moves around the circumference in order to keep as far away as possible from the convention of the day. It is anti-authoritarian, radical and subversive. As the conventions of society move closer, so the disturbing image retreats, keeping the 'acceptable' at a diagonal opposite.

Here is a good example of what I mean. In the 19th century the church held a dominance in societal values. Therefore, some of the most disturbing images, to the Victorians, were those that offended religious notions. A most shocking image depicted an actress against the light, and "the glory round her head is giving great offense." It was a 'blasphemous' image because the woman was aping the Virgin Mary! It is impossible to imagine mere back-lighting being so disturbing in our own secular society. Perhaps Joel-Peter Witkin is fortunate in that his photographs have clashed with a Conservative political trend . . .

It is also curious that images which were not considered disturbing in the 19th century have since become so. Postmortem photography, for example. Today, I venture to say, they are considered rather shocking and brutal in their casual depiction of death. Yet, when made, they were objects of affection. *Tempora mutantur.*

Times are, indeed, changing – and the nature of what disturbs changes with them.

2.
Disturbing the Status Quo

Another definition of disturbance is to break up the settled order of things. A brief note should be made of the application of this definition to photography. It will be very brief because the thrust of this issue is towards the former, more accepted, usage of the word.

Photographers, like all other specialists, cherish the traditions of their field of expertise. New departures create cracks in the shell and signal a period of vulnerability and anxiety. Paul Strand produced such cracks with his brutally direct portraits in 1917, images which cocked a snoot at pretty pictorialism, signalling a conflict epitomized by the verbal battles between Ansel Adams and William Mortensen during the 1930s. Robert Frank disturbed the *status quo* in *The Americans,* not only by disregarding the formal etiquette of Henri Cartier-Bresson but also by injecting existentialist despair into the images of affluent, self-satisfied America of the 1950s. Bill Brandt's *Perspective of Nudes* was also almost universally condemned when it was first published.

After several decades of photography dominated by the 'straight' image, Jerry Uelsmann created a disturbance in the medium with his fantasy blends of the 1960s. At the same time Lee Friedlander and Garry Winogrand were also shaking the visual conventions of the decade with their own idiosyncratic images.

The are many, many other examples. It is impossible to impress on young photographers just how disturbing were the photographs of these individuals when first made because, of course, the images have been encompassed by a new shell and the authors accepted into the pantheon of picture-pioneers.

The point is this: all the innovative image-makers have this tendency to rock the boat in which we feel so comfortable, huddled together with our peers. They disturb the settled order of things – before we let them in the boat and, once again, feel safe, until some other individual starts shaking the vessel.

In this sense, disturbing images are to be welcomed, although it is often

difficult to ascertain the cause of the photographs' offensive nature. If they merely disturb the medium's *status quo*, they will be quickly accepted by the photographic community.

I have tried to indicate that disturbing images are inevitable – and that they are always healthy. Even those which fill us with disgust and abhorrence can indicate that we care about moral values, that we are part of an upsurge in human consciousness. They act, paradoxically, as indicators of the state of our society; they are part of the negative-positive essence of art. Those which disturb us personally can be keys to unlock areas of individual sensitivity, to be cherished or rejected as appropriate. Images which unsettle us *as photographers* can be viewed as signals that the medium is vigorous and energetic no matter how much we loathe them personally.

While images still have the capacity to disturb us, I have hopes for both the human race and the medium of photography.

Body power

THE NAKED TRUTH

No Subject is Politically Incorrect

... A photography exhibition devoted to an historical survey of images
of female and male nudes is so caught up in the 'politics' of the very
meaning of displaying the unclothed body that any other discussions
– aesthetical, moral, technical – seem beside the point ...

The past twenty years have made it impossible to discuss the nude in
photography apart from the political agenda it serves. And what that
agenda includes can be summarized this way: to perpetuate sexual and
racial stereotypes; to deepen the cultural bias and animosity toward
women; to maintain the distance that separates men from women; to
sustain the belief that women, usually (and men, occasionally) are ob-
jects, to be used, bought, traded, sold, and to perpetuate the hold
which the (white) patriarchy has on the culture.*

This assertion is true.

It is true in the sense that a white male who is independent or rash
enough to photograph a nude female will be lambasted for his chauvinistic
gall by disapproving critics, like Ed Osowski, who comprise a dispropor-
tionately large percentage of those writers who fill up the pages of fine-art
photography's periodicals.

It is *not* true in the sense that the assertions, quoted above, are fair,
reasonable or held by the majority of photographers and viewers, male
or female.

If you are a young male photographer, interested in making images of
the female nude, and intimidated by the vocal, strident minority who
dominate photographic criticism, let me offer you a few words of warning

* Ed Osowski, reviewing the exhibition 'Explicit Image II' in *Spot*,
 Summer 1988, p. 19.

about critics and writers (including me), and some good reasons why you should ignore their strictures.

Ideally, photographic criticism should provide one or more of the following services: introduce you to photographers of whom you were unaware; expand your appreciation of a photographer's work; place the images in the context of photography's history; place the images in the context of the artist's culture; and, while accomplishing these services, throw light upon the creative/artistic process. These services demand that the critic demonstrates superior knowledge and insight. The result will be photographic writing which is informative, elevating and, above all else, *useful.*

The problem with so much of photographic writing at present is that it is destructive, mean-spirited and useless to the practicing photographer. Critical opinions should always be taken with a large grain of salt. For the most part, they are manifestations of the critic's debate with himself as to what opinions he should hold in order to be a fully paid up member of the group to which he aspires to belong. These opinions may have no direct relevance to the photographs being discussed.

So when critics tell you that all nudes are political in meaning, what they are really saying is this: in order to be accepted and liked by our peers we have decided that all nudes should be considered political. In this sense, critics are telling you more about themselves than about the photographs.

Remember this. All meaning in photography is *imposed;* it is not intrinsic to the images. Criticism is not a true/false test, with the critic acting as examiner, deciding which images pass and which fail, by the application of an infallible decree. More likely, the image is merely a springboard from which the writer dives into his or her mental pool of doubts, frustrations, complex and competing motives, and subjective fears and wishes. From such a stew of uncertainties and ambiguities we are indeed fortunate if anything of value is dredged.

Let's take a specific example. A female critic recently wrote about the nudes of Edward Weston by saying: "He made nudes so grandly impersonal as to make a woman uneasy." Fair comment. But note the "a". A

woman. Just one. Not "all women" or "Woman" or "some women", but a particular individual. Guess who? This is not nit-picking. What I am attempting to show is that this statement, under the guise of a true assertion, becomes a very personal opinion. The critic is saying: I find E. W.'s nudes unsettling.

She continues:

> He said he meant to obliterate the personal element, so his nudes are intended to represent pure form, but ultimately his denial of their humanity, individuality, and eroticism is distasteful. He hid their faces, less, perhaps, from discretion than from his feeling that they were primarily bodies to be made love to ...

I am so grateful to the writer for slipping in that word 'perhaps', because it, alone, demonstrates a charming vulnerability in a passage which would otherwise ring of authority, masking a personal opinion. (And let us ignore the contradiction that first Weston denies eroticism but then, in the next sentence, feels like making love.) The issue here is that the author thinks that nudes which represent pure form are "distasteful". At this point we have to wonder what is going on. First, Weston stated quite clearly what he intended (pure form) and then is castigated for doing it well; second, the critic presumes, on the evidence of a few photographs, that Weston wanted to make love to all his models; third, if Weston *had* made images reflecting his sexual desire, that would also have been distasteful. The poor guy could not win.

It would be reasonable to assume, from this quotation, that the critic does not like the idea of men photographing naked females, and that Weston's photographs are merely the excuse to express that opinion.

I am not intending to denigrate this particular critic (who happens to be one of the most astute, intelligent and intelligible writers on photography) but to demonstrate that opinions are not fact. Also, I have no objection to a critic telling me, up front and frankly, what artists and images he or she likes and dislikes. This is useful to know. But that is very, very different from laying down the law. The one thing I most emphatically will not tolerate from a critic is he or she telling me what I *ought* to condemn or approve or believe.

And that is precisely what Osowski and his ilk attempt to do. Reread the opening quotation.

It is *impossible,* he says, to discuss (and therefore photograph) the nude without a political agenda. And that agenda is very specific, as the rest of the quotation makes clear. You can read this agenda in writings by many fine art critics. Indeed, it has become the dogma of all 'serious' critics who wish to pander to their peers. It has become the articles of faith by which the adherents are approved and given space in the journals or a platform at conferences, as rewards for devotion to the cause.

It is pure, unadulterated propaganda, the sole purpose of which is to intimidate the reader into the correct (i. e. the critic's) frame of mind. The thunder rolls, the lighting flashes, and out of the darkness strides the stern critic bearing the stone on which is chiselled irrevocably and indelibly: *Thou Shalt Not . . .* Melodramatic hogwash.

So listen to me, young photographer. No one, least of all critics, should be able to tell you what you can or cannot photograph. And no one, least of all critics, should question your motives, through such intimidation, even before you have loaded the camera.

The female nude has been a rich and rewarding subject for photography since the medium was born. Photographers have approached this subject from every conceivable motive and every, infinitely complex, set of desires. Many, it is true, have been ugly, base and destructive. Some, however, have been exquisitely beautiful and elevating. The vast majority have been somewhere in between. Just like everything else in life. So photograph the female nude if you wish. Aspire to greatness and fail. That is your prerogative. I am not advocating the subject because that would be as absurd as forbidding it. *No* subject is forbidden.

Many of you have already been infected by the critic's strictures on photographing nudes, and I sympathize. All I can do is offer you some parting notes of warning and a few words of encouragement.

Remember that critics deal in words, which convey ideas. Photographers deal in images, which convey emotions. The two activities are very different from each other and may, or may not, be useful to each other. Also remember that critics, by and large, are addressing each other

48

– not photographers, not you – and that all their pronouncements are subjective and tentative, sure to drift in other directions with the next wind of change in group-think, no matter how portentously uttered.

As a white male, will you be considered exploitive, chauvinistic and a promoter of sexual stereotypes? Yes, at least by the critics and curators, because there is a bias against this subject, due to the prevailing opinions of the power people. Should this fact deter you or influence the manner in which you create images? No and no – unless of course you expect grants, exhibitions or publications.

But look at it this way: your chances of obtaining grants, exhibitions or publications are almost non-existent unless you are already one of the favored few. So what have you got to lose?

And look at it this way: if you are promoting sexual stereotypes by photographing nudes, then you are promoting racial stereotypes if you photograph blacks, Hispanics, Asians or any other ethnic group. By extension you are guilty of reinforcing stereotypes if you photograph the elderly, children, the poor, the rich, foreigners and tourists, and so on, *ad absurdum*. All this means is that you cannot, if you are desperate to avoid all possible charges of exploitation, photograph anything except rocks and tract-homes and peeling posters. And, believe me, someone is sure to find a political/sexual motivation and meaning even in these subjects.

Can/should photographs be made out of simple, direct sexual attraction and not be exploitive of the female? Of course. Sex has been around a long time and it is here to stay. It is a natural, normal, healthy, life-affirming instinct, and only the walking dead would deny it. It is the genesis of some of the world's greatest art. It is also true that some will prey on this instinct for reasons of greed, rage and corruption, but that does not mean the instinct itself is abhorrent or cannot be utilized to create affirmative images. The only guide you possess in this quest is your own integrity and 'sense of rightness'. You can safely, and righteously, ignore the critics.

If all else fails, use a female pseudonym (for the same reasons some 19th century female writers used male names) and the very different re-

actions of the critics will prove that the image itself is not the issue, but the gender of its maker. And nothing could be more absurd (and sexist) than that . . .

The demands of photography

DIANE ARBUS

A Personal Snapshot

For the past 15 years I have been making snapshot portraits of people in photography. Because I am not a professional, or even desirous of a reputation as a photographer, I can be totally self-indulgent when deciding which frame to print. I have a single, simple criterion in picture selection: the best photograph is the one which reminds me most clearly of the original event, the one which acts as the most potent memory-jogger of the time, the place and, most importantly, the person.

I like this idea because my mind seems to work in the same way even when photography is not involved. When a photographer's name crops up in a conversation, I do not think of biographical facts, the stuff of data sheets. Instead, a specific and personal event of the past, linked to that photographer, slips through my consciousness, tinting my response with a feeling for the memory. These mental 'snapshots' may not be *the* truth about a photographer but they are *my* truth.

I have just finished reading a biography of Diane Arbus, full of dates, facts, exhibition lists, publications and so on. All very useful – but lifeless. The author might as well have been listing the features of a camera as of a human being. My own mental 'snapshot' of Diane Arbus may not be as factual but, for me, it is more truthful.

In 1968 I wrote to her address in New York saying that I planned to visit the city and would like to meet her. She mailed back a curt and succinct three-line scribbled note which said: I don't want to see anyone, but if you insist come on ... And then she added the date and time.

On that morning in September I walked to her apartment building and climbed the stairs. The day was just beginning but already I felt like a wrung-out dishrag from the sweltering New York humidity. I rang the bell and a voice shouted "Go away", which was very disconcerting. So I rang again. Same shout. I rang a third time and the door opened to the

limit of the security chain and a mouth told me to beat it. Hastily, I said who I was and that we had an appointment. The mouth was silent for seconds and then said: "Alright, you can come in, but only if you do not talk about photography!" Now I was the reluctant one, but agreed. The door closed and a lot of scuffling took place. Then I was admitted, and the iron bar re-attached to the steel-plated door and braced on the floor, the locks turned and the chain attached. This was New York.

The apartment was surprisingly airy and spartan, with white-washed walls and very few pieces of furniture in large open spaces. Diane Arbus was small and slim but looked very energetic. I guessed she could be extremely explosive and hot-tempered. She had short dark hair and didn't smile, or observe the usual pleasantries. As she led the way into the kitchen, containing a long wooden table and benches, I noticed she was wearing a black roll-neck sweater and leather mini-skirt. It was quite sexy and she looked a lot younger than her age, which was 45. Although I did not make the analogy at the time, she reminded me in retrospect of a small cuddly animal which had a ferocious bite. She was dangerous.

Diane Arbus noticed my bedraggled look and asked if I would like some jelly. The idea of a cold fruit dessert on such a day was appealing. While she mixed up the contents in a dish, she constantly needled me with remarks like: Photographers are so boring I can't imagine why you would want to see them, or, All magazines tell lies and yours is no exception. The jelly prepared, she placed it in front of me on the table and straddled the bench so that her skirt rode up her thighs, revealing a clear view of her panties. She either did not know, or care, and looked at me belligerently. I took a mouthful of the jelly, and thought I would vomit. It was the most foul-tasting stuff I had ever encountered, like a mixture of dishwashing liquid and gravy. Arbus' eyes were on me. By this time I had had enough, both literally and figuratively. I spat out the mouthful and said: that's the most disgusting stuff and if I have any more I will spew all over your table. I was angry.

Then Arbus astonished me. She suddenly burst out laughing. And at the end of her outburst, said: O. K. Now we can talk about photography.

To this day, I have no idea whether I passed some sort of bizarre test (of what?) or whether she actually enjoyed the 'jelly' concoction, and expected me to eat it. Whatever changed her mind about discussing photography in general, and her own work in particular, also radically changed her personality. For the next few hours she was full of charm, warmth and good humor. And she was articulate, if not voluble, about answering all my questions with disarming frankness. She was delightful. Her bedroom walls were plastered with prints that she was "living with" before deciding if they had merit. I remember she was agonizing at that time over the image of the child playing on a lawn while a couple are spread out on lounge chairs in the background. Eventually she must have decided that it 'works' because since then the image has been frequently published.

Subsequently when I called on other well-known photographers during the same trip I found out that Diane Arbus had called ahead to smooth my way. At the Museum of Modern Art, she was waiting for me in person and was anxious to show me "the best things in the whole collection." From a brown parcel in the back of a cupboard she drew out a stack of prints depicting vaginas with teeth and other equally grotesque and fantastic imagery. "These are from the Kronhausen collection of erotic art," she said, "but they have not been accessioned in case the trustees would object." "Aren't they fantastic," she kept saying, "They're really great, the best photographs in the place," and so on.

So that is my mental snapshot of Diane Arbus. I remember a sensual volatile woman with extremes of mood, but most of all I remember an enigmatic photographer who was already a legend, but who took the time to encourage and assist a young photo-magazine editor.

A few weeks later, back in London, I received a large envelope from New York. Inside was a 16 x 20 inch print of one of her "doubtful" photographs which I had urged her to "accept." Her gift asked me to accept it too.

I never saw her again. Diane Arbus committed suicide in 1971.

The locust-plague of political correctness

CREATING A VIABLE
DIALOGUE SITUATION

About Talking

At a recent conference I heard a photographer ask a colleague if they could "set up a mutual dialogue situation with each other." Such friend-liness was heart-warming but I wondered why they did not 'talk together'. The answer has just occurred to me: in the last sentence I was tempted to place the word 'merely' in front of 'talk', and we all know that merely-anything is not to be recommended. The speaker raised the status of their planned conversation by calling it a 'dialogue' and gave it an added seri-ousness by using nine words when two would suffice. Of course, it does not matter that 'mutual' and 'with each other' are self-cancelling and that 'dialogue' means talking together, so that neither 'mutual' nor 'with each other' is required. The speaker was obeying the rules of language which have recently been set by lecturers and writers on photography. Never use one word when three will say the same thing, and, never use a clear word when you can conceal the triteness of the idea with a camouflage of jargon or pomposity.

I do not expect photographers to be great writers or orators. That is not what I am advocating. There is more at stake in clear, simple com-munication than writing beautiful prose for its own sake. The use of lan-guage that is worthless leads to the propagation of worthless ideas and, inevitably, to the adoption of worthless acts. Language, ideas and actions are inseparable. A good deal of the trite, witless, meaningless photography which is being shown, and praised, today has its roots in our refusal, or inability, to use words precisely. The photographic fashion for art-jargon, puffed up with false erudition, and decorated with complicated construc-tions, reveals an underlying poverty of thought. Photography demands clear thinking. Good ideas demand clear communication. Yet our lan-

guage seems designed to conceal more than it tells, and usually cloaks the shameful nakedness that there is little or nothing worth telling.

Photographers are not alone in their use of gelatinous verbiage. Our culture is a morass of verbal redundancies, repetitions, stuffiness, fake erudition, and trick phrases.

On the flight home from the conference, I had forgotten to pack a novel and therefore listened more carefully to the stewardess. I was instructed to read the booklet in the seat pocket for my personal safety. My safety would have been adequate. I was asked: "For my meal preference, would I like ..." Why 'preference' except that it adds a word? As the plane was about to land, the announcer hoped that I would have a good day in the city "or wherever your final destination may be taking you." With any luck my destination will be static, and not lifting, like a magic carpet, to take me anywhere. My point is that we become immune to such loose language because it surrounds us constantly. Inevitably, we adopt it – and our words, and thoughts, become increasingly vague and imprecise. The free magazine issued by the airline included an interview with the television pundit Andy Rooney. He said: "The brain works like a camera, I guess. Every once in a while you go into the darkroom and develop what you've got in there and you play it back. You cannot sit down and decide to become creative." Exactly. If junk goes in, junk comes out.

We should demand that our teachers, lecturers, and writers speak better English, so that we know what they are talking about and, more importantly, so that *they* do. Photography is healthier when its language is specific. It improves our chances of understanding and we are better able to sift the meaningful from the meaningless.

Perhaps you think that I am exaggerating. Let me offer in evidence the few pieces of mail which had accumulated during the several days of my absence for the conference. The mail about photography included three magazines, two exhibition announcements and an exhibition catalogue. I will not identify the sources because you will be able to find similar examples of stuffiness, pomposity, and fake erudition in any piece of photographic literature at any time.

In the first article I read, for example, "the seeming chaos" of the pictures being reviewed was "controlled by the rationality of the orthogonals." I had no idea what the last word meant and I had to look in three dictionaries before I found a definition: "having a sum of products or an integral that is zero or sometimes one under specified conditions." I still do not know what the writer meant. If the word is so difficult to understand I can only assume that the writer is attempting to impress me with his own genius rather than to help me understand the photographs. He continues that the photographs "gain an added density of signification through their opaqueness in terms of literal meaning." If this means anything, it says the writer is impressed by the pictures because he does not understand them. Signification is a useful word. He rambles on:

> Inasmuch as the 'photographed' is no longer a static object to be studied, but rather evidence of a form or perception which manifests an awareness of the interplay of the opposition of fact and fabrication, the emphasis on signification takes the form of mystery – the mystery of the incarnation of aesthetic meaning in photographic 'language'.

It is a mystery to me, too, and all you can do under such mystification is meditate, as the writer recommends. Needless to say, this complicates the task of writing about these photographs or, as this writer would say – and does say – "of translating affective qualities into a discursive mode."

The writer enjoys words like 'intellectualization' and 'conceptualization' (adding -ization to a willing word is always good for the self-esteem). He uses the words five times in two paragraphs. Sensibly the photographer is "sheltered within the metaphysics of irony," otherwise it could be nasty being out in a storm of -izations.

In a hasty dash through the journals I was showered with a few hybridizations, politicizations, categorizations, personalizations, sensitizations, systematizations and others. Someone even wondered what would happen to photography because of its museumization. I noticed in this article and others that there is a new trend appearing in photographic journalism. I pass it on because many of you I know would not want to be left behind. It is no longer acceptable merely to photograph something; now you have 'an interactive relationship' or 'an interactive experience'

with your subject. A snapshot is a 'spontaneous interactive experience'. With any luck it will also be a mutual and meaningful dialogue situation for you both. Equally grotesque is the phrase 'imaging it through a camera' when 'photographing' has done sterling duty for so long. One exhibition was called "Imagism". Horrid as the word is, it does follow the fashion. I am also pleased to report that most other '-isms' are alive and well. Even though one writer asserts that conceptualism "is basically an art form in the past tense" (and then uses the word at least 7 times) another magazine devotes its whole issue to "Modernism, Revisionism, Pluralism, and Post-Modernism". Unfortunately Minimalism was too insignificant to include in the title, as was Formalism, but both were dealt with in the text, which also included a helpful glossary of all the art '-isms'. Isms are in, along with izations.

I also noticed that photographers do not hand-color or paint their pictures any longer; they apply 'systematic conceptual gestures'. Modern writing is glutted with these pompous, over-stuffed, silly phrases for simple words in common use. These phrases have an obvious appeal. They are new and, if you will forgive me, smack of intellectualization. Because their meanings are not clearly understood, they serve as stumbling blocks to effective communication. Language that is puffed up with phoney erudition acts as a barrier, preventing the reader from taking issue with the writer. The writer is protected inside his wall of jargon, hiding from the possibility, God forbid, that the reader will see that he has nothing to say.

Photography is full of these slippery words and phrases. Edward Weston used to be a 'master' or 'hero'; now he is a 'viable role model for emulation'. Aerial photography has become 'technical overhead reconnaissance'. People do not paint, they 'experience an ongoing arting process'. Students are not lazy, they have 'declining motivational values'. Photographers do not think, they 'conceptualize' (calling ideas concepts is itself a concept). Teachers do not encourage students, they 'emit reinforcers in a learning situation'. Photography does not have its own characteristics, it has 'expanded variables indigenous to the medium'.

These phrases are insidious because they mask the truth. They remind me of the instrument called a nondiscernible microbioinnoculator –

which is a CIA poison dart gun. Or acoustical perfume, which is a noise for offices that sounds like a ventilating system and played just loudly enough to permit private conversations.

In one of the articles there were so many pompous phrases that the point of the piece was all but unintelligible. After struggling through 'quasi-oxymoron', 'the arena of psychoanalytic exegesis', 'synecdoches of their owners', 'anatomical and orgasmic epiphanies', 'intonations of the metaphorical enterprise', I was ready for a few Tylenols. By the way, the article was about family snapshots.

Another writer was talking about close-ups of heads or, as the author would have it: "their original abstraction . . . relaxing their indexical signification" which were "metaphorical landscapes of pain." The pain in my head was real. Somehow these pictures had the effect of "drawing the viewer in, almost unwillingly" into a "confrontation with pre-verbal existence." I am glad I did not go willingly. In a different journal, another writer is also pre-verbal. He talks about a photographer "engaging in the playful vandalism and acting as midwife," which is not to be recommended when taking photographs. However, the first writer in this paragraph did well to match up both indexical and signification. We have already seen that signification is big right now and indexical is getting bigger all the time. It usually occurs in phrases like 'indexical reference to reality', which appeared more than once in this month's magazines. Putting indexical and signification together was a good idea, a viable concept, no less.

As new words become fashionable, you might think that the older favorite cliches would die. Not at all. For example, the faithful standbys of the pseudo-intellectual – paradigm and parameter – are still being used, and used incorrectly. For those who insist on dragging these words into their articles I would suggest they first buy a dictionary and then suggest they note the difference in meaning between parameter and the word that is usually appropriate, perimeter. Better still, they could use 'limit' or 'boundary'. Another word which is so commonly used that it has become inviolate is 'juried', as in 'juried exhibition'. Apart from the fact that it is ugly, there is no such word in correct English. Jury and jurors are nouns; there is no verb to jury. Another commonly used word is

'native', as in 'native American art', meaning Indian art. Does this mean that non-Indian painters are not native, even if they were born in America? If so, the word native becomes nonsense, or the painters should start lining up at the immigration counters for their alien cards.

I have had enough of these bad writers whose main purpose is to confuse rather than clarify, to confound me with complicated constructions when straight talk would be preferable. I think it is embarrassing and frustrating when I want to read about photography and am prevented from doing so by empty-headed, pseudo-intellectual snobs. I am not ill-read and I consider myself fairly intelligent, and I have studied photography for twenty years with love and dedication. Therefore, when I read an article about photography and find it unintelligible due to its pompous jargon I do not feel intimidated, I feel angry. These idiots are destroying the field I care about. I do not feel like engaging in a volatile dialogue situation with them, I feel like shouting at them. And I would scream: *Speak clearly or shut up!*

I say again: Photographers are not expected to be great writers. Errors in usage will be treated with a decent tolerance. The important thing is that the writers are struggling to express ideas as clearly as possible, in direct, specific, concrete, imaginative and vigorous language. If the language conceals more than it tells, it is a fair bet that it conceals the fact that there is little or nothing worth telling. The absence of ideas gets the most pompous language. If you have nothing to say, don't say it. I have become so used to the fact that politicians never speak clearly that I was astonished when Pierre Trudeau declined an invitation to speak at the United Nations because he had nothing sufficiently important to say. He would have received my vote on the basis of that piece of frankness.

Editors must bear a large part of the responsibility for cleaning out the garbage from the photographic press, but they can only publish what is submitted. It is ironic that as photography has become more popular with the public so the language of photography has become more turgid, ponderous and unintelligible. Never before has the importance of clear communication been so imperative. Never before has its lack been so clearly evident.

THEN :

NOW :

PROFESSORS AND PROFESSIONALS

*The Recent Chasm Between Artist and Commercial Photographer
Is Wholly Destructive*

'Professors' and 'Professionals' might share the same linguistic root, but
that is just about all they have in common.

As often as not, the professional photographer views the art professor
in academia as a photographer who was too incompetent to make it in
the professional ranks. The art photographer in academia has the reputa-
tion of being a lazy dilettante, playing with inconsequential, irrelevant
and largely superficial ideas while the mainstream rushes by, uncaringly.
The teacher, it is said, is more concerned with reacting to images in a
meaningless pseudo-intellectual jargon than with exploring the medium
of photography in any significant manner. It follows that the im-
poverished students from academic institutions of photography are amaz-
ingly inept, at everything, and only fitted to find teaching positions in
order to foist similar banalities onto another generation of students.

On the other hand, professional photographers tend to be ignored by
academia as mere hacks who, because of lack of intelligence, moral
scruples or willful ignorance of the medium's history and aesthetic issues,
have compromised with commerce, sold out, reduced themselves to
common tradesmen. The professionals, it is implied, have squandered
photography's rich heritage in order to pander to the demands of a client.
Money, not love of the medium, rules their hearts; "Give the pub-
lic/client the crap they want" is their motivating cry. Professionals, it is
claimed, deserve to be ignored by academia because they have nothing
to offer young photographers in terms of issues, ideas or inspiration.

Have I exaggerated the situation? Perhaps. But all of us have heard
similar sentiments expressed by both professors and professionals. One
fact that is not in dispute is that there is a widening gulf opening up

between art and commercial photography, between professors and professionals. In my lecture travels to colleges and universities around the U.S.A. it is abundantly clear that art programs in photography are becoming increasingly isolated and incestuous – and are in imminent danger of becoming totally irrelevant.

At this point, therefore, I should like to take a personal stance. There is some truth, and a lot of misconceptions, in the attitudes of both professors and professionals as previously outlined – *but the responsibility for creating this alienation lies with academia.* This remark deserves, if not a treatise, certainly more explanation than space permits in this context. However, here are a few notes as the basis of my assertion:

The idea of teaching photography-as-art in colleges and universities is of relatively recent origin. The first MFA in photography graduated in 1946 (from Ohio State University). Photographic education rapidly expanded in the following decade due to the increasing number of mature students attending the universities under the GI Bill. But it was not until the 1960s that the real explosion took place in photographic education. One of the most influential educators at this time was Van Deren Coke who declared: "I do not know how to train artists or photographers; but I do know how to train assistant professors."

The result was that colleges churned out teachers, not photographers, which had a profound effect on the medium's recent history and led to an alienation between academics and professionals. Inevitably.

When teachers train new teachers how to produce yet more teachers, a closed world is created. Most academics arrive at their college or university positions straight from an educational institution and therefore have no experience, knowledge, or interest in, the world of the professional. It seems churlish to expect them to forge links with a field of which they know nothing. Also, most photography courses are located in art departments, where the air is permeated with the ideas, issues, attitudes and history of art (meaning painting, printmaking, sculpture, etc, *not* photography). It is understandable if these faculty and students adopt rag-bag notions of art-attitudes and wrap them around photography. In these particular (art) environments, life is more amenable that way.

66

Having created a closed, self-serving (and historically new) field of photography, the art establishment was quick to produce service organizations for this system. Lecture funds brought other teachers from academia to talk to students; exhibitions were organized – but only by and for academic art photographers; galleries opened up to sell art photography; museums began to buy photographs, primarily by academic/artists; grants and fellowships were offered to photographers, usually those who had an academic base because the selection committees comprised fellow teachers.

And so on. My point is that a specialized area of photography, comprising art-academics, has arisen in the past twenty years which is totally new in the history of the medium and has, by choice and definition, very little connection with photography as practiced by professionals since 1839.

Revealing the wisdom of my age, I will confidently predict that the situation will a.) stay the same or b.) change. The ramifications of each alternative are more difficult to foresee.

If this situation stays the same, as I think is likely, then the gulf of misunderstanding between professors and professionals will widen. Many will say that this, too, is inevitable – and laudable. Advocates of art and academia will state that photography is a potent tool in the hands of artists and that the closer relationship between photography and the other arts is long overdue. Because the advocates of this position have only breathed the rarified air of art schools I can sympathize with the reasons why they would feel this way. But I still disagree. Photography, at its best, is not art; photography is photography. It has its own rich history, unique characteristics, singular strengths (and weaknesses) and clearly-defined principles, most of which are not shared by any other visual art. By denying its basic, core principles in the name of Art, photography is in danger of becoming impotent. My suspicion is that photography-as-art in academia is quickly becoming an irrelevant eddy in the mainstream of photography – and that future history, if it notes this area at all, will accord it merely a footnote.

I hope the situation will change. I hope academics will rejoin the photographic mainstream, by affirming that *the vast majority of the best images*

in the history of the medium have been made by professionals. Let them admit that even their heroes and heroines in recent decades did not sneer at earning their living by doing what they did best – making photographs. Look at the careers of Ansel Adams, Walker Evans, Diane Arbus, Garry Winogrand, Duane Michals, Weegee, Margaret Bourke-White, Elliot Erwitt, Harold Edgerton, and so on and so on and so on.

The problem arises: teachers are not professionals so how do they incorporate professional attitudes into their curricula? They do not make the attempt. They find every opportunity, through lectures, workshops, and exhibitions to introduce students to the work, ideas and attitudes of the very best professionals. They must build bridges of communication across the gulf toward the professional because the roots of their medium are on the other side, away from the artist.

That will take a lot of courage, but the results will be worth the effort.

Academic photography could be a place of affirmation of the principles of photography, a source of rejuvenation of the medium. Professionals have much to learn from the professors; professors have even more to learn from the professionals.

The exhilaration of risk

BILL BRANDT

A True but Fictional First Encounter

You have telephoned Bill Brandt requesting an interview.

His voice is soft, barely above a whisper, and in its slow cadence and precise enunciation you might imagine a European accent (Viennese, perhaps). There is a long pause while he considers your request.

"I do not think so," he says.

You gush about your admiration for his work, that you will only be in London for a short time, how important it is to you that a meeting takes place ... Again, a pause. He then tells you when to arrive, "if you must."

In the residential fringe of London you find his address, a building of soot-darkened grey brick, monolithic and austere. It looks like an institution for political deviants in its sinister functionalism; seedy Graham Greeneland.

The stairs are dark and the tiny elevator is a prison cubicle closed by a crash of sliding metal gates. On the landing you peer through the gloom searching for the door numbers. Bulbs are missing from the light sockets.

At last you confront Bill Brandt. He is not what you might have expected. He is tall and gaunt, and looks like an El Greco saint and indeed he is priest-like in his stern withdrawal and ascetic features. He is not hospitable but neither is he hostile. He seems nervous like a thoroughbred race-horse, and you expect him to shy if you come too close or speak too abruptly. There is no small-talk, he sits opposite you and you are separated by a table, bare except for a few retouching implements. But the print on which he has been working has been removed. Hidden.

In the silence you glance around the room. It has the restrained dimness of an Edwardian interior – dark green walls and deep red drapes held aside by brass clips, solid heavy furniture, shelves of books, a screen containing early (family?) portraits, an old polished mahogany camera and,

on the wall, incongruous fish-bone-and-twig collages. You nervously look back at your host and your first thought, perhaps, is the difficulty of imagining this fragile, long-limbed aristocrat, with his aura of sombre serenity, colliding with the world of parlour-maids, East End pub dwellers and Northern coal-miners.

This interview, you can sense, will be more difficult than you suspected. Where to begin? Why not at the beginning?

"Mr. Brandt," you say (it is inconceivable that anyone could call him plain Bill), "it has been variously reported that you were born in Hamburg, of an English father and German mother, in London of Russian parents, or in Russia of English parents ..."

"Yes." he says. And smiles. You wait, expecting him to elaborate. He is confirming only that his origins have been variously reported.

You try again. "Will you please tell me your background."

"No," he whispers, followed by a long pause.

Usually, when an interview says nothing the other person will make conversation. Brandt remains calm and silent. It is disconcerting. You are losing whatever control you might have had.

"Why not?" you blurt out in frustration.

He sits there, with his long fingers spread out on the table, pale blue eyes over aquiline nose, gazing out the window at bare winter branches. Eventually, he says: "The person is of no importance. It is the picture that is important ... " His whisper trails away.

You start to disagree; biography, you insist, can increase understanding of the picture. But you are merely making noise, and begin to feel like a raucous intruder, as if shouting in church.

"I thought you wanted to talk about my photographs," he says. "If that is not your reason for being here, perhaps you should leave." Again he diffidently smiles, softening the sharpness of his words.

You sink into yourself and become aware of something that you should have known but which has been drowned in the cacophony of personal needs and wishes. It is this: Bill Brandt does not need anything, least of all from you. He does not need your questions, or your curiosity, or your opinions. Above all, he does not need your approval. Only an old-world

courtesy has allowed you this meeting. Only your selfishness prompted this invasion of his privacy. You feel uncouth and rude.

"You are a difficult man to interview," you tell him. He smiles but say nothing.

"Have you any regrets?"

"No," he says, as adamantly as he can. Then, more gently, after a long pause, "I like to be left alone."

"Perhaps I should leave," you reply, hoping he will contradict you.

"Yes," he says. "Good."

You feel abashed and slightly indignant. Perhaps this sense of unfocused grievance prompts in you a final ill-considered remark.

As Brandt walks you to the door, you pass a room which might be his darkroom. You ask if you might look in. He denies you. "What is it, then, the Holy of Holies?" you blurt out.

Bill Brandt thinks for a while and then says, "Yes!" and ushers you out. He is not smiling.

Outside the building, the day has also turned grey and brooding, and in the alleys and doorways and facades of suburbia Bill Brandt photographs mock you.

But there is a postscript.

If you can swallow your sense of defeat born of pride, you will make another appointment. And then another.

You now know the ground-rules and the game board becomes familiar, losing its alienness. And you discover that, with patience, the silences are pregnant – not barren; that he can be, will be, forthcoming about his photographs if he respects your desire to understand. You begin to understand that in order to learn from Brandt and his work you must approach them with a sensitized but blank mind and, by contrast, you learn how often you approach people and ideas with pre-developed images, rejecting those which do not conform to the already-known.

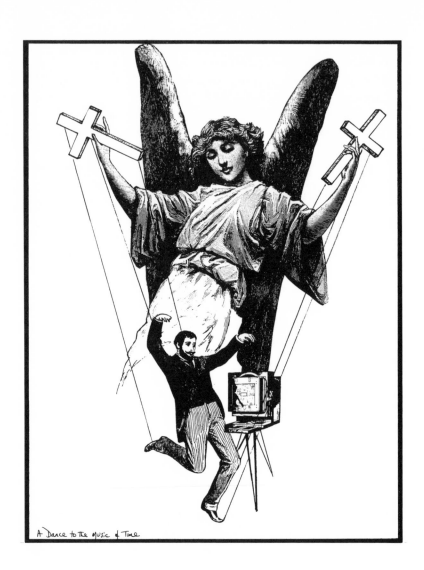

A Dance to the Music of Time

SO MUCH FOR INDIVIDUALITY

Shaken Up in the Cosmic Kaleidoscope

If there is one aspect of their work which photographers (and photographic writers) cherish above all others it is *individuality*. The photograph/article may not be a perfect expression of purpose, may not be instantly and urgently needed by others, may not be recognized for its historical significance and may not be cherished by anyone, ever. But, at least, we believe, it is singularly and uniquely our own. It is a humbling thought that even this meagre justification for our efforts is based on a false premise. Originality is not only over-valued but also, in many cases, of dubious provenance.

I point the finger of accusation at myself. A couple of years ago, I wrote a short piece called "Bill Brandt: a true but fictional first encounter" which was published in a photographic periodical. When another magazine requested permission to reprint it I read it again in order to see if it needed any revision. I say to you, immodestly, that it sounded just right. I hoped it would entertain and inform other photographers interested in Brandt's work but, if nothing else, I thought it had the ring of authenticity. It was *mine*.

Pride goeth before a fall alright. While congratulating myself on a piece well done, a student asked to see my Brandt file. Browsing through its contents I stumbled across a photo-copy of an article which described a visit to Brandt made by the author of the piece. With a palpable shock I recognized a distinct similarity of tone and even the use of identical phrases between this article and my own. Unfortunately the photo-copy chopped off the source of the article but, by typeface and layout it looks like it may have come from a small circulation journal in London, called *Camerawork* (not the San Francisco periodical of the same name). The point is that I have no memory of having previously seen this article but there it was in my file where it had languished for, I guess, ten years or

so. What I had thought of as 'mine' owed a great deal to someone else. I had obviously read this article when it first appeared, recognized not only the similarities of experience but also the aptness of the language, and then appropriated what I wanted to retain while expunging the remainder from memory.

I tell you this experience not in order to absolve myself from a charge of plagiarism (the chances of anyone being familiar with the article are small and, more important, of anyone but myself seeing the connection is almost non-existent) but to illustrate the point that this process happens relentlessly, continuously and subconsciously. Our cherished individuality is largely an amalgam of a myriad of forces and influences which, only occasionally, can be sorted, seen and acknowledged.

But even when the connection between present act or attitude and past experience remains hidden the directness of the link is the crudest form of influence. Far, far more powerful and mysterious are the forces which seem to bypass the word, image or event and which shape our minds merely through the act of being human. The most potent influences result from breathing the same air, existing at the same time in history, sharing in the phenomenon of telepathic group-think. The Germans have a word for it: *Zeitgeist*. Like a flock of birds instantly and simultaneously changing directions on command from an unseen choreographer, issuing orders at the deepest level of non-awareness, we whirl in synchronous patterns. And these patterns are manifested in our medium as styles, even subject matter.

There was a time when these patterns were broad, sustained sweeps and lazy curves, when photographers acknowledged shared ideals. In recent decades the patterns have become increasingly jagged and frenetic with photographers more anxious to escape the group-mind. (Perhaps the group-mind *is* seeming chaos.) I cannot imagine how these forces operate, only acknowledge their results.

Think of all the short-lived 'movements' in the medium in recent years when dozens of photographers simultaneously made almost identical images. The examples are legion. The scratching/mutilation of the negative prior to printing; industrial buildings on construction sites; flash combined

76

with daylight – 'pop and jiggle' pix; constructions in the studio; interior corners of abandoned buildings and garages; Diana plastic camera snaps; and so on, and so on.

What is the process by which the *zeitgeist* becomes transmuted into such specific photographic techniques and subjects? Why are these manifestations happening with such frequency that they appear to be/are occurring simultaneously? I do not know the answers although I am intrigued by the questions.

During a conversation about these issues one of my colleagues saw nothing mysterious about the process. According to him, the phenomenon can be explained by more rapid communication between photographers through a plethora of journals, exhibitions, lectures etc. Ideas are now quickly disseminated, used up and discarded.

A less charitable colleague explains it as the bandwagon-syndrome. Someone else is getting attention from a particular idea so jump aboard before being left behind by the latest trend.

Yet another colleague suggests that pluralism, by definition, is differentness for differentness' sake. When so many photographers are striving for uniqueness certain solutions to photographic problems will be shared. These individuals will be 'grouped' by critics and galleries *as if* they were members of a movement, thereby creating artificial styles.

I feel sure that all these, and other, explanations are appropriate in some cases. Nevertheless I am also convinced that another, more mysterious, force is operating, providing similar images to various photographers simultaneously, without any overt, direct connection between individuals.

Personally I find the idea a comforting one.

Although it seems to diminish our much-beloved contemporary notions of individuality, it also suggests a cosmic-scale connectedness which includes human behavior – right down to the microcosm of shared interest by photographers in specific subject matter, beyond the realm of mere coincidence.

Or, to be more accurate, " ... within the realm of natural coincidences." Around the turn of the century a brilliant Viennese experimental biologist,

with the delightfully photographic name of Paul Kammerer, spent 20 years studying coincidences. His results turned on its head the usual meaning of the word. He concluded that " … The recurrence of identical or similar data in contiguous areas of space or time is a simple empirical fact which has to be accepted and which cannot be explained by coincidences – or rather, which makes coincidence rule to such an extent that the concept of coincidence is negated." He believed that a mysterious force acts on everything (and everyone) to bring like and like together, which he poetically compared to a cosmic kaleidoscope, creating patterns "in spite of constant shufflings and rearrangements." Changing the analogy, "it is," he said, "the umbilical cord that connects thought, feeling, science and art with the womb of the universe that gave birth to them."

Incidentally, a recent *Nova* television program dealt with the new Chaos Theory and, as far as I could understand, revealed that even unpredictable actions and events always produced distinct patterns, which seemed uncannily similar to Kammerer's kaleidoscope idea.

The point is that photographs, like everything else, can be expected to fall into specific, synchronous 'patterns' at any given moment. But because these patterns are unpredictable and out of the individual's control they are not useful in any practical sense.

Much more controllable, and therefore useful, is willful influence. As we are constantly influenced by the ideas and images of others anyway, perhaps we should make greater effort to make these influences more overt and direct. Lionel Trilling said: "The immature artist imitates. Mature artists steal."

The pretence of individuality is a sham so let each photographer/writer directly, openly, unabashedly acknowledge the extent of the plagiarism. As Thornton Wilder admitted: "I do borrow from other writers, *shamelessly*!" (His emphasis) He continued: "I can only say in my defense, like the woman brought before the judge on a charge of kleptomania, 'I do steal; but, your Honor, only from the very best stores.' "

One day I will discover who wrote the article in my files on Bill Brandt and then I can unashamedly write to him or her and say: "I stole your words because I needed them. Thank you."

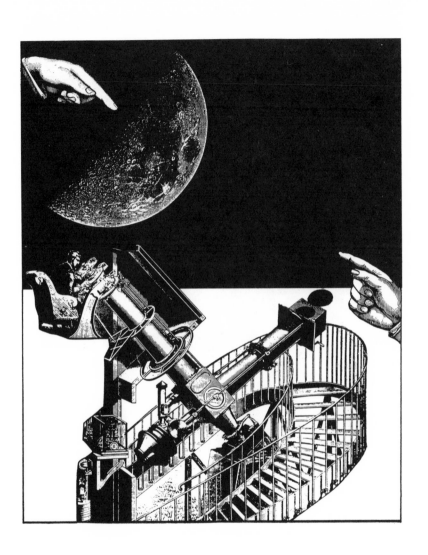

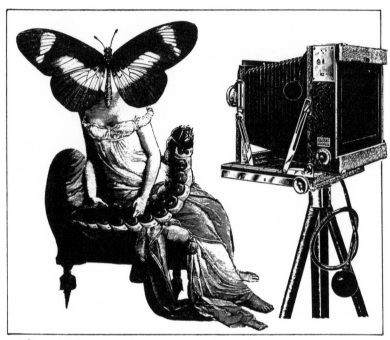

Mother and baby photograph

SOMETHING FISHY

For Robert Heinecken

In a recent tome about philosophical/psychological alternatives propounded by the major thinkers of history, the author expended thousands of words in much earnest wringing-of-the-hands about The Reason For It All. He impressed me greatly with his conclusion: "There is something bloody fishy about human existence."

Trawling around in these murky depths is Robert Heinecken. And what he catches, and offers for our consumption, is redolent of fishiness. This is particularly true in the series Recto/Verso when seemingly random conjunctions of unpredictable facts so consistently create recognizable, and significant, images out of chaotic elements.

Now and again, others have landed similar images by a fluke. There was a bit of a flap a few months ago when a local woman was startled to see Jesus' face emerging from a frying taco shell. The taco was consecrated, not consumed, and the image became a shrine to hundreds of pilgrims. And if I remember correctly, Elvis recently appeared in the mold of an old refrigerator. But my favorite example is an uncited newspaper clipping pinned up over the xerox machine in our art department. A likeness of a patron saint has miraculously appeared on the scrotum of a fifteen-year-old Italian. (The account included a photograph of the scrotum image, so it must be true.) Pilgrims are flocking to the house which God has blessed, where the boy, Giuseppi, displays his holy scrotum through a hole in a screen. Giuseppi is philosophical about God's visitation: "The Lord has picked my testicles to do his work," he says. "I wish he had picked my friend Arturo's, but that's life." It sure is. As Woody Allen said "... the Cartesian dictum 'I think, therefore I am' might be better expressed, 'Hey, there goes Edna with a saxophone.' " Image is more interesting than abstraction.

Both Robert and Giuseppi share a faith in possibilities; the difference between them, however, is not of kind but of consistency. Heinecken seems to have a psychic resonance with these residual images which become even more significant because of their frequency and degrees of latency. As he has said: "I have the feeling that there are things happening that are really very interesting things, if we can somehow find the key that makes them visible."

I cannot find an image of Jesus, Elvis or even a common Saint in the particular Recto/Verso assigned to me – but there are plenty of other fishy things going on. I squint, revolve the page, and all sorts of latent images are brain developed. There's a squatting nude, grinning typographical teeth, vomiting a sub sandwich (ham and cheese by the look of it) into a gaping maw, the lips pulled apart by a giant's limbs; directing the flow is a Barbie doll in sunglasses displaying provocatively enlarged breasts. A slight turn and there's a voodoo mask chomping on a severed leg. Turn again and puckered ruby lips have opened to accept a glowing cigar butt. A further turn and a graceful swan's head is thrusting its beak between ivory thighs. And so on . . .

These 'interpretations' are no less *there* than the more overt surface manifestations. As has been pointed out already, the title piece of 'Are You Rea?' not only includes the anagrams ARE and REA but also suggests ERA, both for the time in which we live and the Equal Rights Amendment. There is also Rea . . as in 'Real' or 'Ready' when the trigger is a woman holding open her blouse. I can never see this title without associating 'You Rea' with 'Eureka', a cry of discovery.

If Robert Heinecken can dredge the photograms of magazine pages for so many strange, beguiling and even meaningful associations and images, the question becomes one of chance or coincidence. I am referring, of course, to the hoary analogy of a particularly obsessed monkey eventually typing a Shakespeare play. Equating the artist with a monkey (even one as tenacious as this) seems rather insensitive, like Tammy Faye Bakker interviewing an armless woman on The PTL Club and asking, "Well, how do you put on your makeup?" I feel justified in posing the above, similarly impertinent, question because I have a point to make which, to me, strikes

at the essence of the Recto/Verso series. In order to make the point I must first re-introduce Paul Kammerer. Paul Kammerer was an Austrian biologist whose professional passion was the proving of the Lamarckian theory of evolution. (He shot himself when it was discovered that his prize specimen, the so-called 'mid-wife toad', had been tampered with to fake the evidence.) Kammerer's avocation, outside biology, was his conviction that apparent single coincidences are merely tips of the iceberg which happen to catch our attention. In other words, he reverses the skeptic's argument that out of a myriad of random events we only select those which seem significant. To Kammerer, 'coincidences' are the rule, not the exception. He believed that there is an as-yet undiscovered law which clusters non-causal concurrences into significant lumps. This, to Kammerer, "is a simple empirical fact which has to be accepted and which cannot be explained by coincidence – or rather, which makes coincidence rule to such an extent that the concept of coincidence itself is negated."

In a beautiful analogy, Kammerer likened this force to a 'cosmic kaleidoscope' which, in spite of constant shufflings and random rearrangements, also takes care to bring like and like together – and to create recognizable, and relevant, juxtapositions by chance, as in the Recto/Verso series.

We may be condemned, because of our humanness, to play the role of "Peeping Toms at the keyhole of eternity," as Koestler says in a similar analogy, but Robert Heinecken has removed the stuffing out of the hole, giving us a clearer look at even our limited view. What Heinecken states as his interest in 'residual reality' bears an uncanny resemblance to Kammerer's 'seriality' (and, it might be added, to Jung's 'synchronicity' and Pauli's 'exclusion principle' and Hardy's 'psychic blueprint' and so on). Unfortunately such terms sound pretentious, as if the idea was too difficult for non-specialists. As Goethe put it: "When the mind is at sea, a new word provides a raft." In fact, the principle is simple, if heretical.

What Heinecken reveals in his series Recto/Verso is that the explanation of coincidence just will not wash, that underlying such randomness is a remarkable symmetry as if Something was trying to tell us something. And that is not only 'bloody fishy' it is also the meaning of art.

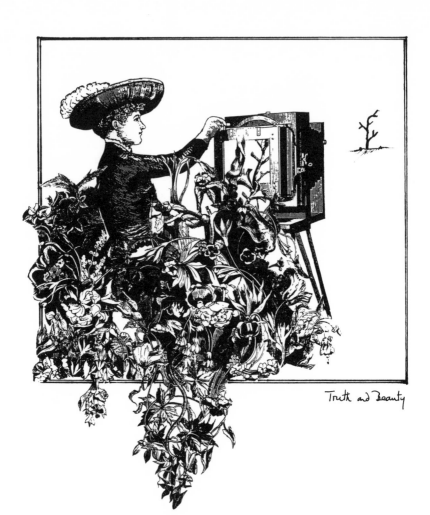

Truth and Beauty

THE FAMILY OF MAN

A Reappraisal of 'The Greatest Exhibition of All Time'

An exhibition of photographs, called *The Family of Man,* opened at the Museum of Modern Art, New York, on 26 January 1955. It subsequently traveled to several cities in the USA and then to 69 exhibition venues in 37 foreign countries. Measured by the number of people who visited the exhibition, or bought its catalogue, *The Family of Man* is probably the most successful exhibition in the history of photography. It is also, probably, the most controversial – in the sense that serious photographers seem to still disparage the exhibition's intents and achievements whenever its name is mentioned. This fact, in itself, is significant when the exhibition is more than thirty years old.

In addition there are many middle-aged photographers who might have been too young in 1955 (or were uninterested in photography at the time) who did not see the exhibition but still hold vague prejudices against the show due to picking up assumptions and insinuations through their conversations or readings. Then again, there is the new generation of photographers who may never have heard of *The Family of Man.*

For the latter, especially, it is necessary to itemize a few facts about *The Family of Man,* and the astonishing nature of its success, before examining the reasons for its low esteem among the photo–intelligentsia.

The Family of Man was organized by Edward Steichen who had been the Director of the Department of Photography at The Museum of Modern Art since July 1947. In the following eight years of his tenure, all the exhibitions arranged by Steichen were historical, didactic or artistic. All of them placed emphasis on the *photographer.* (This is an important point which will be reviewed later in the article.)

In order to provide a few examples, the following exhibitions of photographs were organized by Steichen for the Museum prior to *The Family of Man.*

Historical shows included: *Photo-Secession Group* (1948); *Roots of Photography: Hill-Adamson, Cameron* (1949); *Roots of French Photography* (1949); *Lewis Carroll Photographs* (1950); *Then, 1839, and Now, 1952* (1952). Didactic exhibitions, deliberately organized for their teaching potential and their influence on young photographers, included: *Music and Musicians* (1947); *In and Out of Focus* (1948); *The Exact Instant* (1949); *All Color Photography* (1950); and, the most didactic of all, a series of shows entitled *Diogenes with a Camera* (beginning in 1952). The idea of this series was to "demonstrate various ways, from literal representation to abstraction, in which photographers approach the truth." Showcases for individual talent included: *Three Young Photographers: Leonard McCombe, Wayne Miller* (who later became Steichen's assistant on *The Family of Man*), *Homer Page* (1947); *Four Photographers: Lisette Model, Bill Brandt, Ted Croner and Harry Callahan* (1948); *Six Women Photographers: Margaret Bourke-White, Helen Levitt, Dorothea Lange, Tana Hoban, and Hazel and Frieda Larsen* (1949); *Five French Photographers: Brassai, Cartier-Bresson, Doisneau, Ronis, Izis* (1951); and so on.

Although these lists of exhibitions at the Museum between 1947 and 1955 are brief selections, they will serve to indicate the pattern which Steichen had set – and which the photographic community had come to expect.

The Family of Man defied expectations, as we will discover.

Steichen began preparations for *The Family of Man* in 1952. In that year he visited 29 cities in 11 European countries in his quest for photographs which would fit his theme. At the same time, through press releases and interviews, Steichen requested submissions from all and sundry. Any camera owner could send in prints, however rough, as long as they were unmounted and no larger than 8 x 10 inches in size. Even contact prints were acceptable (except from 35 mm). In exchange, Steichen promised that all submissions would be acknowledged but that no prints would be returned and no payments or prizes would be awarded for any photographs.

The response was astonishing – over *two million* photographs "from every corner of the earth" were submitted.

Right from the start of the project, Steichen's premise for the exhibition was clear. It is worth quoting his statement in detail, in order to clarify his intent and the purpose of *The Family of Man*. Steichen wrote:

> We are seeking photographs covering the gamut of human relations, particularly the hard-to-find photographs of the everydayness in the relationships of man to himself, to his family, to the community, and to the world we live in. Our field is from babies to philosophers, from the kindergarten to the university, from the child's home-made toys to scientific research, from tribal councils of primitive peoples to the councils of the United Nations. We are interested in lovers and marriage and child-bearing, in the family unit with its joys, trials, and tribulations, its deep-rooted devotions and its antagonisms. We want to show the selflessness of mother love and the sense of security she gives to her children and to the home she creates with all its magnificence, heartaches, and exaltations, and the guiding hand of the father toward his son. There can be special emphasis on children, as the universality of man is not only accepted but taken for granted among children. We are concerned with the individual family unit as it exists all over the world and its reactions to the beginnings of life and following through to death and burial ...

As Steichen acknowledged, this would be "one of the most ambitious photographic undertakings attempted by any art museum."

During 1954, the two million photographs were edited down to 10,000 possibles, and finally cut to 503 images, representing 273 photographers (163 Americans) from 68 countries.

The selects were then specially printed from original negatives (borrowed from the photographers) in order to fit the exhibition, designed by architect Paul Rudolph. The photographer had no choice in the print size: the individuality of the photographer and the integrity of the image were submerged (some would say, subverted) into the exhibition's thematic premise and its design requirements. Some prints were blown up to mural size while others were tiny album-size; some images were isolated on screens, while others were free hanging or overlapped with different pictures; images were mounted on transparent walls, or cut out as free standing silhouettes, or placed on revolving stands.

Carl Sandburg (Steichen's brother-in-law) wrote a short but fulsome prologue and the exhibition opened at the Museum of Modern Art on 26 January 1955, filling the whole second floor.

The Family of Man was a photographic phenomenon – at least to the public.

In the first two weeks, more than 35,000 viewers flocked to see it, "smashing all previous attendance records for any photographic exhibition ever held by the museum." In one day (22 February – a national holiday: Washington's Birthday), 6,000 people attended the show, which was "the most spectacular attendance record in the museum's 25 year history." Each day, long lines waited outside the Museum for the doors to open: "They lined up outside the Museum as at movie theaters." When the show closed at MOMA (103 days later), more than 270,000 viewers had seen it, "the largest in American photography exhibition history."

The Family of Man then toured the USA, with venues at Minneapolis (where per capita attendance was even greater than in New York), Dallas, Cleveland, Philadelphia, Baltimore and Pittsburgh.

The exhibition, in all these cities, "received heavier press coverage than any comparable 'artistic' event in our history."

The catalogue to the exhibition was equally successful. It was published initially in two versions: a $1.00 paperback (later reduced to fifty cents) and a $10.00 deluxe hardback version. The catalogue included every image in the exhibition (although not in the same sequence or presentation), the prologue by Sandburg, and an introduction by Steichen. Its editor was Jerry Mason and the pictures' captions were written by Dorothy Norman.

Within three weeks of publication, the dollar edition alone had sold 250,000 copies and bookstores throughout New York reported that it was at the top of their best seller list. By 1961, it had sold over one million copies and had reached ten editions. One columnist believed that "*The Family of Man* will become as much a part of the family library as the Bible."

At the close of the exhibition's American tour, it travelled abroad under the auspices of the United States Information Agency.

It travelled to 37 countries (69 exhibition venues), and was equally adored in such diverse cultures as South Africa and Japan, and Russia and Guatemala. *The Family of Man* was extraordinarily popular wherever it went. An American visitor to Guatemala, for example, described how thousands of Indians came down from the hills, barefooted and on mules, to stand, transfixed, before these photographs.

By the end of its world tour in 1961, it was estimated that *The Family of Man* exhibition had been seen, in person, by nine million people. Add to this figure the unknown millions who have seen the catalogue in the intervening thirty plus years and the result is the single most successful exhibition/publication in photographic history.

Steichen was showered with honors. Among others, he received the Newspaper Guild's Front Page Award, and awards from the American Society of Magazine Photographers, the Philadelphia Museum School of Art, the National Urban League and Kappa Alpha Mu for the "Greatest of all photography exhibitions." He was awarded several Honorary Doctorates, the Silver Progress Medal from The Royal Photographic Society of Great Britain, and the first Annual Award from Nippon Kogaku "for outstanding achievement in fostering international understanding through photography."

But if Steichen emerged as photography's most persuasive salesman and the public wholeheartedly embraced the exhibition's dramatic gesture of reverence for the one-ness of Man throughout the World, the photographic community was less than enthusiastic. The attitude of photographers which emerged from the photographic press was largely non-committal, often churlish and occasionally outright condemnatory. There was not a single aspect of the exhibition which was not criticized by photographers – its presentation, its ideological premise, its reflection of a personal (i.e. Steichen's) bias, lack of emphasis on individual photographers, its exclusion of 'creative' photography, its use of quotations (from Genesis to Joyce), and, of course, its inclusion of specific images.

A few specific comments will provide a flavor of this criticism:

The very concept of *The Family of Man* is rather trite. What is worse it is based on ignorance if not a lie.

It is an awesome exercise in naivete, oversimplification, and sentimentality.

One is asked to accept its cosmic One Man declaration and to fight through its pretentious presentation ... a display so elaborate that the photographs become less important than the methods of displaying them.

Mr. Steichen's choice is the surface of things, reproduced as clearly as possible with a nice moderate respectable gloss.

... some people object that *The Family of Man* is not art at all, but a social and anthropological document, and ... ought to be moved from its present location to the Museum of Natural History.

What is disheartening is to see the agency (Museum of Modern Art) which claims to preside over the artistic values of photography tumble so easily into ... vulgar ideological postures.

It would be possible to provide scores of quotations along similar lines, and many more dealing with specific attacks on individual images ("the picture of the father and boy would be useful for an illustration in *Parents Magazine* or an ad for baby food") or on other aspects of the exhibition. Sandburg's prologue was "a heavy dose of this verbosity, which reads like nothing so much as a schoolboy imitating a young American poet of forty years ago ..."

But the point is already clear enough: in spite of, often because of, *The Family of Man's* phenomenal public success, the photo-intelligentsia disowned it – and has been faintly embarrassed by it since 1955.

After a gap of more than thirty years, it might be possible to place the exhibition and its unfortunate reputation into context and perspective.

Leaving aside subjective quibbles, such as Sandburg's "verbosity" or the disagreements over the inclusion of specific images, the major issues which have sullied *The Family of Man* can be discussed under two general topics: 1.) photography and 2.) ideology.

The photographic issue is quite clear: *The Family of Man* made no attempt to stress the unique image as the creative result of a special individual. This was not photography as Art but photography as communication, in the service of a theme, which not only took precedence but also totally subjugated the individuality of both image and author.

To photographers in the 1950s this was a crushing blow. For decades, photographers had coped with a sense of artistic inferiority. There was precious little, if any, support for personal image-making from grants and fellowships; galleries and museums rarely showed photographs; there were only a handful of academic institutions in the U.S. which treated photography with any degree of seriousness; few monographs were published and generally photographers lived isolated creative lives, rebuffed as serious image-makers and relegated by society to the status of wedding photographers or news cameramen.

The one flowering oasis in this creative desert was the Museum of Modern Art. From Steichen's appointment as Director of Photography in 1947, photographers had a champion, a spiritual leader and, through his exhibitions, a sense that they belonged to a wider community of dedicated artists.

Steichen's exhibitions, as already noted, stressed the continuing rich history of the medium, taught young photographers, through the images of master photographers, the principles of creativity with a camera, and selected individuals whose work was displayed with as much care and attention and seriousness as that by any artist in any other medium. By 1950, Jacob Deschin (*Say It With Your Camera,* McGraw-Hill Book Co., Inc.) was echoing the consensus of opinion among the ranks of photographers when he declared: "Steichen must be considered chiefly as the symbol and the hope of all forward-looking photographers who would like to see camera work placed on the high level in public opinion now enjoyed by other arts." One reason for this extraordinary reputation was that Steichen's exhibitions at the Museum of Modern Art, prior to 1955, gave full attention to the photograph as Art, and to the photographer as a serious, committed, creative individual who ranked equally with any artist, whether in painting, sculpture, music or poetry.

The Family of Man shattered that emphasis on the individuality and uniqueness of the photographic image. Now, photographs were merely subservient to the theme, relegated, once again, to the status of journalistic or advertising illustrations. What did it matter if the theme was a moral one? The photographs were not displayed as monuments to the

medium but as symbolic pictures, like individual letters in a sentence. It was the totality of the photographs, The Theme, which drew attention, not individual images which only served to reinforce the idea. At that time, 1955, Steichen's *volte face* in his stand on photographic exhibitions was shocking in its suddenness and startling because, in the absence of any other photographic activity of equal importance, all eyes were on the Museum of Modern Art.

This sudden disrespect for photography, as it seemed, especially from such a revered figure as Steichen, was compounded by Rudolph's exhibition design. Not only were images blended into the show's theme, but also they were "mistreated" – blown up, hung from ceilings, stuck on revolving "merry-go-rounds", cut out into silhouettes, made into horizontal tables, curved around poles, stuck on top of one another and so on.

It is understandable why photographers were disappointed or infuriated. Steichen was not only fraternizing with the enemy (the public) but was paying his way into its favor with the currency (photographs) of his friends. No wonder the friends, the photographic community, felt betrayed.

The opposing viewpoint is that 'betrayal' is only appropriate if the 'betrayed' were not forewarned and aware of the action, and did not actively contribute to its success.

Yet, right from the beginning stages of *The Family of Man,* Steichen made his approach, and his justification, abundantly clear. He intended to use photography for a moral purpose, not a demonstration of photographic art. "This exhibition," Steichen explained, "will require photographs made in all parts of the world, of the gamut of life from birth to death with emphasis on the everyday relationships of man to himself, to his family, to the community and to the world we live in." He saw the exhibition "as a mirror of the essential oneness of mankind throughout the world." *The Family of Man,* he affirmed in the closing sentence of the exhibition's introduction, "has been created in a passionate spirit of devoted love and faith in man." He did not say ... in a passionate spirit of devoted love and faith in photography, which is what photographers

wanted to hear – and which they had expected from Steichen's previous exhibitions.

Implicit in the exhibition's intent is the idea of a mass audience. Photographers and connoisseurs of photography were intended viewers of the show only in that they were members of the family of man. As John Stanley wrote in *The Commonweal* (1 July 1955):

> But it was not really a photographic exhibition; its *raison d'être* was not to show the techniques or the history of photography, nor to praise the photographers, professional and amateurs, living and dead; its *raison d'être* was the praise and appreciation of the human family in the silencing variety of its conditions – and the promotion of love.

The whole point of the show was to generate warmth and good feeling among the maximum number of people throughout the world – not to promote photography or photographers. The critics, then, attacked the exhibition for not accomplishing what it never intended. Steichen was playing a different game, with different rules.

One of these 'rules' was that the photograph had to be intelligible, at least on a subject matter level, to the intended audience, which included both Muscovites and Guatemalan Indians. The vast majority of the photographs, therefore, were of the documentary/journalistic type. Content over Form.

Just to confuse matters, Steichen, perhaps to assuage the photographic critics, asserted that *The Family of Man* was "an exhibition of creative photography ... " But as Phoebe Lou Adams pointed out (*Atlantic Monthly*, April 1955): "Creative seems not quite the right term for this style. Transferred to writing, for instance, it would put a news reporter in the same line of business as a writer." This is a debatable point, of course, but it should not obscure the issue which disturbed photographers: *The Family of Man* left "the art of photography exactly where it was before, suffering from widespread confusion about its aesthetic status – a confusion which *The Family of Man* itself has now done so much to congeal" (Hilton Kramer, *Commentary*, October 1955.)

In the mid-1950s, photographers were obsessed, even more so than now, with the art claims and social status of the medium. Steichen was

expected to continue in his role as their champion for these claims. By 'pandering' to mass appeal, he had let them down.

It should be emphasized at this point that photographers did not believe that Steichen had lowered his photographic standards and included "less than the best." Indeed, the contributors to *The Family of Man* read like a Who's Who of great photographers of the '50s (including, to mention a few credit lines from the opening pages of the catalogue: Wynn Bullock, Roy de Carava, Louis Faurer, Robert Doisneau, Ernst Haas, Wayne Miller, Werner Bischof, Robert Capa, Henri Cartier-Bresson, Elliot Erwitt, George Rodger, Manual Alvarez Bravo, Robert Frank, Irving Penn, Alfred Eisenstaedt, Bill Brandt, Russell Lee, W. Eugene Smith and so on).

The objection was that these photographers had not been highlighted as Artists but that their images were mere illustrations of a theme.

This Theme – Steichen's notion of the essential oneness of mankind – received the most devastating criticism. His "devoted love and faith in man" and his touching faith in the ability of photography to reflect this notion, seems excessively naive, sentimental and even mawkish in our own cynical era. But there is no doubting Steichen's sincerity or the responsive chord which it struck among the public.

The timing of the exhibition could not have been more appropriate – at least in America. Fear of Communism, for example, had reached an unprecedented level in the early 1950s, epitomized by the executions of Julius and Ethel Rosenberg in 1953 and the televised public hearing of charges of Communist subversion by Sen. Joseph McCarthy in 1954. The U. S. Senate voted to condemn McCarthy in December, producing a sudden thaw in the Cold War – and *The Family of Man* opened the following month. The 'Geneva Spirit' of accord and peace dominated the political process, following the summit meeting in July the same year. "Suddenly," as one political columnist enthused, "you, (Americans) are catapulted into a world completely beyond your worries and concerns of the moment" (Augusta Strong, *Daily Worker*, 1955). Americans relaxed, and threw themselves wholeheartedly into the pursuit of The American Dream. Personal and family happiness prevailed and a spirit of optimism lasted

through the rest of the decade, swamping individual opposition to the good life. Initial publication of *The Americans* by Robert Frank, a more sombre, critical view of American culture, was an obvious photographic victim of this rampant determination to see the country, and the world, through rose-colored spectacles.

The Family of Man reflected, and reinforced, this sunny vision of humanity; Steichen's romantic ideology perfectly coincided with what the public wanted to hear, and see.

Steichen demonstrated his notion of the oneness of Mankind by sorting the photographs in sections, each one of which shows people of varied races and nationalities engaged in similar kinds of activity. In order of the exhibition, it is discovered that people fall in love, get married, have children, go to work, while the children go to school, enjoy themselves by singing and dancing, eat and drink and then they die. But Mankind survives and the exhibition closes with romping children and, last of all, in Eugene Smith's *'Walk to Paradise Garden',* depicting his own children emerging from darkness into glorious sunshine.

Steichen's effigy of the human race is virtuous, patient, loving, pious, hard-working, and noble. It endures the threat of extinction (represented by a single image: a color photograph of an atomic explosion) and emerges into a Utopia populated by happy children. *Voilà.* Mankind is not only all one, it is all good.

Critics of *The Family of Man* did not need to stretch their faculties in order to discover that this view of humanity was slightly myopic. And it was Steichen's *ideology,* his illusionary image of the world (not as it was, but as he wanted to believe it was) that made photographers uncomfortable with, or embarrassed by, the exhibition. Steichen, the intellectual/artistic giant of contemporaneous photography, was seen as a simple (some claimed simple-minded) romantic of pygmy political acumen.

A few critics were incensed beyond mere embarrassment, considering Steichen's view of mankind to be both artistically and politically dangerous. Perhaps the most cogent and lucid of these critics was Hilton Kramer. Writing under the title "The World's Most Talked About Photographs" (*Commentary,* October 1955), he lambasted the exhibition.which "embo-

dies all that is most facile, abstract, sentimental, and rhetorical in liberal ideology"; he castigates "the vacancy of thought which characterizes this notion of 'relatedness'"; he reminds us "of how little reality is represented in this visual morality play"; he regrets that photography is peculiarly vulnerable to "this sort of ideological infection"; and he is disheartened to see that "artistic values of photography tumble so easily into the vulgar ideological postures."

But this is more than artistic quibbling, insists Kramer. Steichen's use of photography in *The Family of Man* has far more important, political, repercussions:

> (It is) a self congratulatory means for obscuring under a blanket of ideology which takes for granted the essential goodness, innocence, and moral superiority of the international 'little man', 'the man in the street', the abstract, disembodied hero of a world-view which regards itself as superior to mere politics. The *Family of Man* is thus a reassertion in visual terms of all that has been discredited in progressive ideology.

The political ramifications implicit in Steichen's show deserve closer scrutiny, but they are not relevant in this context except to note the outer fringe of criticism. It would also be unfair to note photographers'/critics' reactions to the exhibition without off-setting Kramer's political agitation with a more enthusiastic response. The painter Ben Shahn (who appears as a photographer in *The Family of Man*) was quoted in *The American Artist* (May 1955):

> Let us also note that it is not at all surprising that the public turns to the Steichen show with such undivided enthusiasm. The reason is, I am sure, that the public is impatient for some exercise of its faculties; it is hungry for thinking, for feeling, for real experience; it is eager for some new philosophical outlook, for new kinds of truth; it wants contact with live minds; it wants to feel compassion; it wants to grow emotionally and intellectually; it wants to live. In past times all this has been largely the function of art. If art today repudiates this role, can we wonder that the public turns to photography ...?

In conclusion: there are no conclusions.

Photographers will continue to view *The Family of Man* with some feelings of trepidation in that it raises questions about the artistic, social,

cultural and political roles of the medium which have yet to be answered. Indeed, *The Family of Man* is a microcosm of all the issues which have haunted photography throughout its history. And that is why the exhibition is so unsettling to photographers. To 'the man in the street' these issues are irrelevant: he/she continues to enjoy the show. Perhaps Steichen was right. Perhaps his "devoted love and faith in man" was not so naive after all. Perhaps, among the more than nine million viewers, some lives were irrevocably changed. Perhaps, therefore, the world today, for all its faults, is marginally more peaceful, secure and happy because of the ideals shared through the exhibition's images.

Viewers viewed

PAST PERFECT

The Relevance of the History of Photography to Contemporary Artists

Recently I was sitting with a group of photography teachers who were discussing the sharp drop in student enrollments at their university, and the necessity for cutting out several classes. One of the academics – the one with the biggest name as an art photographer – was clear about the course of action. "Obviously," he said, "eliminate classes in the history of photography. History is irrelevant." What was irrelevant, to him, was that the history of photography classes included the most students, which made it obvious that the decision was based less on efficiency and more on personal prejudice.

'History is irrelevant' is not a new prejudice. It has been heard throughout the past of practically every medium, including painting. It is a particularly stupid assertion that is voiced by either the truly ignorant or the pseudo-intellectual. And it is a particularly dangerous assertion at this point in the medium's development when the history of photography is beginning to be discussed, written about and taught with increasing frequency.

I would like to offer a few words of encouragement to those who a) are finding themselves intrigued by their medium's past, b) are worried by the jibes of the I-hate-history crowd and c) do not consider themselves crassly ignorant, pompously academic in attitude, or excessively bigoted.

1. An interest in the history of photography is a natural, inevitable result of being a serious photographer. I have never met a really committed photographer of any stature who was not fascinated and fed by a knowledge of the medium's past. In addition, the important photographers are interested in anything and everything about the medium which impinges on their own love for picture-making with a camera. To the truly committed photographer *everything* is relevant and directly

useful. This seems such an obvious fact that it can be something of a measure of a photographer's merit. Go to movies with photographers and hear how they relate the style, character, plot or whatever to their art; listen to them discuss the books they last read, recent events in their lives, newspaper stories, concerts attended, and so on. Whatever they do has a direct and immediately applicable relevance to their own passion. How much more relevant, then, is the history of their own medium?

A natural corollary of being interested in any subject is for the mind to 'spread out' and absorb the surrounding topics. True concentration on any subject vibrates the web-of-connectedness until the idea of irrelevancy becomes an absurd notion. Therefore, to say "History is irrelevant" is unnatural and deliberately perverse.

2. The critics of history might point to the field of art history (the history of painting) where there does, so often, seem to be an unbridgeable gulf between the practising artist and the academic historian, with their mutual suspicion and dislike, and language and attitudes which have grown so far apart that they are deaf to each other's screams for recognition.

Fortunately that stage has not yet been reached in photography. But we must face the fact that it is coming – unless we can keep out the prejudices of the I-hate-history crowd. Up to this point in the medium's history, all the best photographic historians (including Beaumont Newhall and Helmut Gernsheim) have also been practising photographers. That is important. Photography aesthetics are rooted in process, and it is essential that the historian has an intimate relationship with the equipment, materials, chemicals and practical problems of the medium. The alternative is a dry, aloof – and irrelevant – history. That is often the result when 'pure' art historians approach the history of photography.

A single example will suffice. I once heard a lecture by an art historian who examined several photo-albums of the 1860s in which were discovered a large proportion of prints of trees without leaves. The lecturer, in a detailed, scholarly paper, drew several conclusions from this

fact – such as: the photographer as Romantic, brooding on death and destruction, the need for the young art to mimic motifs in etching and painting, etc. These observations may have been valid, or not, but the main point was missed. Anyone who knew about photography (and had read the 19th century literature) would have known that the cause of the leafless trees was rooted in process, not art. The simple fact is that the collodion process necessitated long exposures (commonly twenty seconds for a landscape), during which time the leaves of a summer tree blew in the wind and produced blurs on the plate. In those days, blurs were abhorred and so the photographer waited for winter when the production of a sharply detailed image was more practical.

The point is this: historians can become excessively academic and irrelevant, but that is not a condemnation of history itself.

3. It is not only true that all the best historians have been familiar with the practice of photography but also it is true that the best photographers have been among the medium's most important contributors to our knowledge of its history. For example, we owe our recognition of Eugene Atget in large part to the efforts of Berenice Abbott. The astonishing early work of Jacques Henri Lartigue, the boy-wonder of photography, was brought to our attention by John Szarkowski (himself a practising and published photographer). Ansel Adams performed this service for Timothy O'Sullivan. In 1937, when asked to contribute to the Museum of Modern Art's first major show of photography, Adams sent with his own work a collection of original prints by O'Sullivan, and a note which said: "A few of the photographs are extraordinary – as fine as anything I have ever seen." O'Sullivan was then practically unknown, and might have long lain forgotten except for the enthusiasm of a photographer for the medium's history.

Photographers of the past have always been the medium's most energetic and successful 'historians'. And now we are led to believe, by some pseudo-intellectuals, that all their efforts were "irrelevant." What incredible arrogance!

4. Those who claim that history is irrelevant are condemning themselves, and their images, to be forever faddish, blindly following the latest

trend and stylistic fashion in images. There can be no assurance without a deeply felt past: like a tree without roots there is always the risk that the next wind of change will destroy the art. This is the great fallacy of the age, that something is better because it is new. As Dr. Aaron Scharf once wrote with beguiling passion:

It is the vogue today to reject the past – as though one really can. The cheek of some people! And what narcissism! History can't teach ME anything! I project MY trivia onto history, thus it can only, must only, deal in trivia. So help me! History is nothing but a useless collection of facts, dates, and other irrelevancies! There you have 'modern' man, the quick-results man, the man of action with a Lilliputian mind.

One of the curses of contemporary photography is that it only feeds on last week's output, emulating and elevating style over meaning, lauding banality over deeply held convictions. Photographers owe it to the medium, and to themselves, to escape this impasse by acknowledging and embracing the lessons of history. When it is understood from where you have come, it is with more confidence you know where you are going. Think of a boat on an uncharted sea out of sight of land. One way to be sure that you are not sailing in circles is to drop buoys over the edge. By looking back at these 'pasts' you can plot a more forward-looking future.

The history of photography is relevant because the past illuminates the future.

5. The history of photography is not an objective list of names, dates, processes and other irrelevant facts. And if you hold this point of view then you have missed the whole purpose of history. History is a palpable, pertinent, recognizable force for enriching the whole of life, not merely the aspect called photography. History is the story of individuals' dreams, their aspirations, their disillusionments, their cries of protest at being human, their challenges to fate in the face of defeat, and their shouts of joy in moments of victory over self and nature. History lives, and breathes life into minds dulled by 'relevancy.' Through history we share the experiences of others who know what it was like to struggle with a medium as recalcitrant as photography.

History acknowledges their presence in our work today; through history the masters of the past talk to us of hope for the future.

That is what history means. And anyone who considers history irrelevant is a self-confessed, and self-destructive, fool.

6. To say "History is irrelevant" makes no more sense than to say "my birth and subsequent history to date are irrelevant." Whether a photographer is aware of it or not the history of the medium determines, in a very real way, the appearance of every picture which he or she produces today. As in the law, ignorance is no excuse. There is not a photographer alive and working at this moment, no matter how indifferent to history, who is not profoundly affected as an inevitable result of the accumulated images of the past. These are every contemporary photographer's heritage, the collective memory of the medium, and there is no escape from history while still remaining human. All islands might seem isolated yet they are connected by the same seabed and washed by the same waves.

History is relevant by the very fact that it *is* our history.

7. The history of photography did not come to an abrupt end in 1900, or in 1950, in any other years of the past. History includes whatever you are doing right now. And here is the final point: whatever images are being produced at this moment in time not only add to the medium's history but also *the works of the past are being renewed by the best work of the present*. Each new image subtly, but irrevocably, changes the past as it contributes to the future.

Every photographer is Janus, the two-headed Roman god, who could not look forward without looking back.

Life tends to repeat itself

ORIGINAL (and Reproduction) THOUGHTS

The Difference Between a Picture and its Price-tag

In April 1987, Van Gogh's painting of *Sunflowers* sold at auction in London for 22.5 million pounds (plus 2.25 million pounds commission). That's nearly $40 million.

The Art World will never be the same again.

Not that I care.

When art becomes a game which can only be played by mega-millionares, you will excuse me if I decline to participate. Especially when I calculate that my total gross income for the whole of my working life would not be adequate to buy this single painting. In fact, it would not even buy one of the 15 sunflowers in the work. So, the deal has solved one of life's decisions: I am now resigned to never owning an original Van Gogh; sometimes one must make sacrifices in order to keep oneself in bathroom tissue.

Having excused myself from any personal involvement in this issue, I can still muse on the meaning of it all. And there are several issues which spring to mind.

The artist's sense of self-worth, for example. We hear so much about the gargantuan egos of artists it is refreshing to note that Van Gogh considered the painting to be worth $40, at 1889 value of course. (In today's prices that would be about $1,440) Needless to say, no buyer was available during Van Gogh's lifetime and he was condemned to a lifetime of frustration and poverty. Then, as now, if you want to be famous and increase the value of your art, it is a good strategy to die.

Perhaps Van Gogh should have stuck to his original occupation: art dealer. For a few minutes of hammer holding and the ability to differentiate between a bid and a nose-pick, Christie's auction house picked up a cool $4 million in fees.

An obvious reaction to such huge amounts spent on a painting is to speculate on what else could have been done with so much money, a figure which would make a healthy difference in the gross national product of several countries. It could have bought hospitals, schools and houses in abundance. But the problem, of course, is that people with $40 million to blow on a single painting are not likely to dwell on the more essential elements of survival, such as health, education and shelter. They do not have to attend to the more prosaic details of life, such as taking out the trash, feeding the dog, or pushing a cart around a supermarket.

More puzzling is why such individuals do not buy thousands of paintings by aspiring artists around the world. This would increase the excitement of the game because there is a chance that among the collection would be works by a contemporary 'Van Gogh', condemned to a life of penury until discovered by a mega-buck patron. Perhaps such collectors do exist, but they do not receive the international media blitz which accompanied the Van Gogh sale.

What about photographs?

Let's assume that fine art prints by contemporary photographers have an average price-tag of $400. The price of *Sunflowers,* therefore, would buy 100,000 photographs. That's a nifty collection. The only problem is that this would be more than the total production of worthy fine-art prints during the lifetime of every artist-photographer. I knew there was a snag somewhere in the scheme.

Perhaps it was not Van Gogh's art which was such an attraction. Perhaps the unknown buyer (reputedly a Japanese businessman) was crazy about sunflowers. Then my advice would be to buy an original print of every sunflower photograph made by Paul Caponigro in the late 1960s ('*Sunflower*', Paul Caponigro, Filmhouse Inc., N.Y. 1974) – and get back more than $39,950,000 in change. If given a choice between fifty sunflower prints by Caponigro or one painting by Van Gogh, I would plumb for the former with no hesitation whatsoever.

In case this remark is construed as an antipathy towards Van Gogh's painting, let me quickly add – you are probably right. Well, not antipathy

so much as a sort of take-it-or-leave-it indifference, bred by over-familiarity. It is true that this familiarity has been gained from reproductions rather than from the painting itself. (It is, let's face it, one of the most reproduced paintings in the whole of art history). This makes a difference. But how much of a difference?

Undoubtedly, the original painting has a greater 'presence' and provides, therefore, greater viewing pleasure than even the finest reproduction. But, with hand and heart, can I honestly say that the increase in satisfaction is worth $40 million? Color reproduction techniques have become so sophisticated that a top quality reproduction of '*Sunflowers*' (say, by Athena) means that you have to rub your fingers over the surface in order to tell that the brush strokes are not real.

If that is true with a painting, think of the reproduction fidelity possible with a photograph.

In a recent conversation, Eliot Porter was bemoaning the fugitive nature of dyes in color photography, the inconvenience of making color separation negatives and locking them away in a vault in order that quality prints could be made at a later date, and the expense and time involved in dye-transfers, and so on. So what's new? Then he dropped his own version of 'a bombshell dropped at a tea-party': that laser-scanned color reproductions of his photographs were not only more convenient, cheaper and permanent than the originals, but also of *higher quality*. This may have been an example of hyperbole, but I do not think so.

Where to draw the line between original and reproduction has always been a moot question in the history of photography. Early daguerreotypes were copied and issued as original albumen prints. Albumen prints were re-photographed and the copy prints sold as originals (often under the names of different photographers). Photographers sold carbon, woodburytype, collotype, photogravure, and a host of other, reproductions as the 'original' state – for precisely the same reason as Porter, because they were cheaper and more permanent than the silver prints. Julia Margaret Cameron albumens were reissued as carbon prints (often hand-colored) long after her death.

More recently, Ansel Adam's first book, *Making a Photograph* (1935) included lacquered, tipped-in *halftones* which most reviewers thought were original prints. There are many other examples.

Often, the reproduction was made for aesthetic reasons, because the printed image looked better than the silver image. The Photo-Secessionists, including Alfred Stieglitz and Alvin Langdon, issued photogravures as originals. Single pages of reproductions from *Camera Work* often sell for more money than most contemporary fine-art photographs.

Even today the difference between an original print, a copy print and a reproduction is a hazy area.

The last exhibition of prints by Bill Brandt, which I saw shortly before his death, is a case in point. The gallery director proudly displayed them with the assurance that every print had been purchased directly from Brandt. As I was particularly interested in Brandt's work, I studied each print with care. I then casually remarked how interesting it was that Brandt was now issuing copy prints as signed originals. The gallery director screamed "What!" and threw a fit of pique, feeling that he had been cheated. To Brandt, I am sure, the making of copy negatives from master prints was merely an obvious solution to an otherwise lengthy and tedious printing problem.

Another anecdote. I visited a small college of photography and was delighted and astounded to find on the corridor walls an amazing collection of prints, all carefully matted and framed. There were images by Cartier-Bresson, Weston, Adams, Strand, Stieglitz, Cameron, Brandt *et al*. A veritable cornucopia of goodies, all hanging for the students' edification and inspiration. I collared the program's director and congratulated him on the quality of work, and asked him how he had managed to obtain such great prints on what was obviously a meagre budget. He smiled and whispered in my ear. They were pages torn out of monographs! I rushed back to the exhibition – and still could not tell, in most cases, that they were reproductions.

Fair enough, there are some images in the history of the medium where such reproductions would not pass muster, but very, very few. With modern methods of superb reproduction (see Bruce Barnbaum's

monograph, *Visual Symphony*) and the nature of photography, I doubt if many viewers, if any, could spot the difference between most originals and the best reproductions, especially when matted and under glass.

For dealers and hustlers, this issue must be a matter of concern. Let them squirm. For most of us, it merely means that we have more access to fine images at minimal cost.

The fact that thousands of other viewers are getting the same pleasure from a reproduction of the identical image only increases my satisfaction in the ubiquitous and democratic nature of photography.

Self-portrait under trying conditions

W. EUGENE SMITH

A Personal Snapshot

In the autumn of 1969 W. Eugene Smith thought that his life – both creatively and literally – was over. He was 51. He believed he was ready for death and that suicide was the honorable way out. He felt that he was ugly, unloved, unappreciated and incapable of further work. He was wrong on all points.

It was an appropriately stormy November night (Gene embraced melodrama) when I was woken at 3 a. m. by the incessant ringing of the telephone in my English village home. Stumbling out of bed, down the stairs and into the kitchen, I picked up the receiver to hear Gene's hesitant, incoherent voice crackling over the wires from New York City. He told me he had mailed a package of original prints to be used as his obituary in my magazine *Album*. "By the time you receive them, I will be dead," he said. He insisted that he was going to commit suicide, "Maybe, tonight."

I begged and pleaded, to no avail. "Keep my prints as an epitaph," he insisted, while I urged him to call a friend in New York ("I have none") or come to England for a vacation ("I would only drag you down in despair"). I screamed at him that he was loved, even revered, and that he could not do this thing to us all. But he broke the connection. I called him back, only to exchange the same conversation. Gene was going to die.

I spent the rest of the night frantically trying to contact mutual friends in New York, in a frenzy every time I received a discontinued line or no answer. At last, a contact. He listened to my panic and told me not to worry, I was overreacting and that Gene was exaggerating. I hung up confused and hurt, convinced that the call confirmed the New Yorker's callousness and cruelty, not knowing in my naivety what his closer friends understood all too well: that Gene was probing, pleading for affection.

A short time later the package of original prints arrived. They were a mixed lot, odd sizes and formats, old favorites and previously unpublished images, some very personal in their sexual explicitness. They were all mounted onto black card.

On 17 January 1970 a three-page, single spaced letter arrived. It, too was full of agonizing personal turmoil and repeated intentions to "committt (sic) suicide." In part, it reads:

In the fog of tiredness I was under when I sent those prints off to you I believe I scribbled something and promised you a letter. This may or may not be the letter. I have slept for many hours, I still am tired and confused as to what the situation is. And I know I have to scramble "practical" things if I am able to cope with the financial onslaughts of today.

One of the several reasons that I now waver so close to suicide is that I know I am becoming more and more self-unreliable. I held sacred my promises – deadlines (if agreed to) among them – and I fiercely fought my professional obligations. Yes, I fought deadlines – I fought such as the hysteria of deadline being applied to the pyramids. I fought useless and arbitrary deadlines. When I agreed to a deadline for some valid reason I too often worked my heart and gut out and hurt things and situations very important to me to prove my word to responsibility.

In poverty and in sickness and in times where I have had to divert my attentions to make sure I still had electricity for the enlarger – these have been the times I have become so split and weak that I have not been sure I could even try to continue towards a deadline.

I am unreliable now – and since I really allow myself no excuses is one of the reasons I think I should move towards suicide. I think I have been lousy towards you. And I sadly cherish the kindness you have shown me. And deeply apologize for the spots of trouble I may have placed you in.

I should be stronger than this. I often have been. But I'm sick and battered and financially broke – and ...I am riding a tangled parachute of despair ...

I think these are reasons enough for me to committt suicide and not hang up those who still somewhat believe in me. My being alive is no importance (other than detrimental) if its effect is to demean all of those efforts, beliefs, and crusades to which I so long and so completely have given the dedications of my life.

I doubt I can find another (love of a woman) to keep me alive. I doubt if I

can find other individual strength. I know how battered and ugly my body is
— shot up, crippled, so disfigured. I change not in my present agony any belief
that I would have fought for a different journalistic-photographic validity. I
might wish I have managed it with a greater intelligence — but if I have to pay
this terrible agony for that fight. Let me pay it. That I have lost that love,
have hurt my family as it has cost me. I must pay, I guess — but it is a
damnation.

What can I ask now, of those who call me as friend, other than that when I
am unloved and battered and alienated from comfort — and in that vital fact
of being unable to maintain those standards and that integrity for that kind of
journalism I feel is essential to the worlds survival — what can I ask now, other
than that to those I have meant something to that they will really attempt to
understand why I must in failure to maintain my standards — why I must
committ suicide . . .

I see clumsy and confusing sentences above. I am too tired to correct them. I
guess this is one of the symptoms of needing death.

But — to celebrate any sorrow at my death — remember how much I do love
life, how I have exalted in it, and in the fact that I am seldom bored.

So few changes could mean the differences between my producing and living —
but that is like a snapping of fingers.

And life is as easily snapped off.

There was more, much more of the same, written in a tone of desperation.
I have also omitted large chunks which refer to a woman whose love he
had lost. He ended with the insistence that "I am really wavering so close
to suicide. I say it not as melodrama . . . "

Three days later another letter arrived, a "P. S." as he titled it. After
some talk of his images, and of his lost love, he ended on a more positive
note:

Dear Bill,

 P.S.

If I could beat this depression — if I could fall in love — if there were at least
someone around to make me eat semi-healthfully — if I could get six months
rest. It is not that my belief and zest for living has disappeared — it is, I must
repeat, that I feel I am demeaning those standards I most believe in, and am
further imprisoned by my poverty.

113

But life, fierce (not against others) but in its self fire – in love and belief and desire. It is all still here, even if flipped a bit off the track.

Again, my warmest regards,

Gene

The letter was prophetic. "If I could fall in love ...," he wished. And he could, and did. There was a new woman in his life and life itself was transformed. Within three months of embracing suicide he was rushing towards life and joy. And he asked for all his prints to be returned. They would no longer be needed, at least for an obituary. Gene learned that he could be loved, "ugly" as he claimed to be, and that yes, indeed, he was needed. There is a very old saying: a man dies when his house is finished. Gene's house was not finished. One task remained ...

With a surge of well-being he did what he, and all great photographers, did best: he objectified his state of grace by taking and employing his pictures in order to elevate others.

Within a year he was in Minimata Bay, Japan, with his second wife Aileen, where, from 1971 to 1975, they exposed the agonizing human cost of industrial pollution. Gene was severely beaten up by company goons but, although bloody, he was unbowed. He was capable of further work of humanistic power and social relevancy.

Minimata finished his 'house'. W. Eugene Smith died in 1978.

The solar-powered, people-eating picture-producer

THE ETHICAL ANARCHIST

Frank Capa-Smith has been called "The-greatest-photojournalist-the-universe-has-ever-known." It's on his letterhead. Who better to talk to concerning ethics than the photographer whose bumper sticker reads: "Shoot 'em all, let God sort 'em out." He was a difficult man to find because no one knew what he looked like due to his habit of pocketing huge fees for magazine assignments and sending Photo 1 students from the local community college to shoot the pictures "for the experience." Eventually I caught up with him at his office stool in Flanagan's Bar and Grill – and not before time. He died a few days later, friendless but not alone because he had amassed a huge number of enemies, all of whom were photojournalists.

Books and movies are always depicting photojournalists as hustlers and voyeurs. Is that fair?

No, of course not. It is typical liberal namby-pamby understatement. Photographers are also paranoid, aggressive and utterly selfish. Like Sontag said, all photographers are sublimated rapists and murderers.

What a nasty think to say about your colleagues!

It depends on how you look at it. Photojournalism is a nasty job, but someone has to do the dirty work of life, like pumping out septic tanks.

Why?

Otherwise the septic tanks would back up and overflow ...

No, I mean why is photojournalism a dirty job?

Because photography is pandering to, and encouraging, the dumbing of the human mind. The average attention span of an adult American is 2.4 seconds and falling fast. Reading, therefore, is a major effort. Looking

at pictures is simple by comparison – and the viewers do not need to follow lines with their fingers. So, more dumb people demand more pictures (the dumber the better) in their periodicals so they can become dumber and demand more dumb pictures ... Circulation shoots up, and revenues pour in, and publishers appear on *Lifestyles of the Rich and Famous* while photographers are kept in kennels until they are sicced on another dumb victim ...

Hold on a minute, Frank. I can't let you get away with such slander. I know photojournalists who really and truly care. Just the other day, I heard a photographer in raptures about cosmic peace through pictures, or something.

Yeah, and it's pinko commie perverts like that who give photography a bad name. Perhaps you have noticed it is the second-rate photographers who talk the most about 'integrity' and 'honor'. They are the idiots who talk as if they are the specially appointed guardians of truth in our culture. What arrogance. What stupidity to take themselves so seriously. I tell you, if our culture is being propped up by photographers then we are in deeper trouble than anyone realizes. Next, they will be forming religious sects with themselves as gurus. Then they will not be photographers, but Artists ...

Well, no, I would not go that far but you must agree that photojournalists are providing objective information about reality.

Nonsense. Photography, like travel, merely serves to confirm already held prejudices. Show me a citizen of Dubuque who has 'done' Mexico and I'll show you someone whose Epiphany is that the Meaning of Life is a trip to the Mall in an air-conditioned Caddy. Photographs of foreign places are the same, without the flies and smells. There is *no* intrinsic meaning in any photograph. Meaning is always supplied by the viewer and what he or she wants (or is pre-programmed) to believe is reinforced by the image. I mean, take a snapshot of a pretzel: in the commie press, it's an illustration of orgiastic self-indulgence by capitalist running-dogs; in the right-wing press it's an example of basic foodstuffs denied to the starving masses of wherever; in an art gallery it's a metaphor for a post-modernistic concept exploring rituals of charged spaces, or some such gobbledygook.

I can't believe what I'm hearing. Are you really suggesting that photographs have no positive value?

The value of photojournalism is to the *photographer*. Observing the oddities and absurdities of human behavior (from a safe distance and shielded from corruption by the camera), the photographer learns a great deal about life and his or her relationship to it. Indeed, the photographer is about the only real, authentic human type left in the world. The remainder of humanity might as well be nuked, although I would not advocate it merely because then there would be no one left to photograph.

I don't get it. First you slander photojournalists, then you praise them. You said earlier that they were aggressive . . .

What's wrong with being aggressive? Without aggression we'd still be living in trees. It has been the fuel which has powered all mankind's advances. Photographers *should* be aggressive. Society's problems stem from passivity, the state of being unquestioning, obedient little consumers of half-truths, hypocrisies, shoddiness and the second-rate. We need more anger and indignation, not less. Photographers are real people because they don't play dead; they don't accept life but fight back and attempt to beat it into submission.

Isn't that what photojournalists are doing, fighting life, when they shed light on society's ills?

Yes, but you are being either dense or obstreperous. My point is that, for all photography's grandiose claims, the net result in solving society's problems through pictures is nil. However, by making the effort to do so, photographers as individuals are being transformed into more alert, independent human beings.

But at the expense of other people? Invading their privacy?

Sure. Why not? Someone's gain is someone's loss – always. It's a law of Zen or physics or something. Anyway, 95% of the human race has no higher function in life but to become objects in someone else's picture. Remember the daguerreotype, by Daguerre himself, taken out his window of the boulevard? The exposure time was so long the street seems empty of life, except for a foreground figure of a man who stood still (to have his shoes shined) long enough to register on the plate. He therefore

goes down in history as the first human being ever to be recorded by the camera. He's immortal – and that's more than can be said of practically all people in all of time.

What about the photojournalists who are 'socially concerned', who take pictures in slums, refugee camps, war-ravaged cities and shanties?

Most of the time it's a mere humanitarian pose. The more affluent the photographer, the more poverty in the picture. It's much more honest for a photographer to admit his interest is in the picture, not in the subject matter. Contrary to what the critics and pundits say, you cannot convince me that Cartier-Bresson, for example, is a humanist.

Well, I certainly see them in that way, that is, as expressions of a shared humanity . . .

Which only goes to prove what I have been saying about photographs confirming what you *want* to see, rather than what is there. The people in his pictures are mere tonal blobs, included because the design of the image necessitates something being in that spot. The fact that the blobs are moving in random and unpredictable patterns merely increases the complexity of the game for the photographer. It sharpens the photographer's skill, which, by and large is pretty useless, like keeping thirty plates spinning on the end of sticks.

You don't like Cartier-Bresson's photographs?

I love them. They are great *pictures*. I'm just sick of them being labelled warm, compassionate, humanistic or some other puke word. They exist as Cartier-Bresson's 'thing'. That's what he does. It just so happens that what he did for himself had a side effect: it provided him with a living because he could sell the extras as magazine illustrations.

But many of the best images end up as exhibition prints, and become art. How do you equate this paradox?

Easily. There is no difference in motivation – self-knowledge – between the artist and the photojournalist. They both shoot a lot of pictures in their struggle to reach the perfect expression of their intent. The artist mounts and overmats one image and the rest are useless. The photojournalist also exhibits the deserving few but sells the less-than-best to magazines. Same difference.

Several times you mentioned "self-knowledge" as the motive behind all serious photography. But that can be easily construed as selfishness. Is that moral?

You might as well ask if peeing is moral. If you have to do it, you have to do it. It's a biological imperative, like making pictures. That zoo man, what's his name (Desmond Morris – editor) has said that all image-making is the equivalent of a dog cocking its leg. It is stating "I was here", marking its territory. That's what photographers do every time they make an exposure. Morality has nothing to do with it.

Even if you are exploiting other people?

There you go again, using charged language, like "exploiting." Typical of writer airheads who have limited practical experience. Let me give you a simple situation which every photographer has encountered. You are at a people event – a party, ball, exhibition opening or whatever. A group sees you approach with a camera. Do the subjects cringe, back off, slide away? Nooo ... they entice you, hamming it up for the camera. Why? Because, for a fraction of a second, they have been singled out for special attention; they have been given the benediction of the flash because they think they matter and everyone else will assume they are significant if they have been chosen by the photographer. They never contact you later for a print. That's irrelevant. What they wanted was that moment of attention, blessed by light. Is that exploitation?

In a way, it is. If they saw the picture reproduced, and if it offended their sense of dignity, they might sue you.

They might – because they regret acting like idiots and/or because they know a sharpie lawyer and see an opportunity for a fast buck. Now *that's* exploitation and immoral, not the photograph. If they didn't want to be photographed they should have stayed at home, or worn a yashmak. Britain has a sensible law which warns citizens that one of the risks of appearing in public is the likelihood of being photographed.

You do not think a person has a right to his or her own image?

Of course I don't. That's just another clever ruse foisted on a gullible public by lawyers to give themselves yet another opportunity to bilk supposed victims out of more money. Think about it. Does it make sense to claim you own *light,* just because it happened to reflect off your body?

Think about something else. Who gets sued in these cases? Not the average poor-joe photographer showing pictures in the foyer of the local YMCA. It's the big circulation magazine or the rich and famous photographer. Which only goes to prove that the real issue is money, not morality.

OK, I get the picture, if you will excuse the pun. What you are saying is that photographers should be able to act with impunity and callously shoot whatever suits their purpose without any regard for fair-play or common decency. Right?

Wrong. Your knee-jerk liberalism is exceedingly irritating ...

And you are nothing but an anarchist!

Thank you, although I'm aware you meant the term as an insult, which only goes to prove your ignorance of politics as well as photography. Anarchy, let me enlighten you, holds that all forms of governmental authority are unnecessary and undesirable; it advocates a society based on voluntary cooperation. So, in photography at least I readily admit I'm an anarchist. No rules!

Which means no responsibility, I presume.

Again, you presume too much. I will make one more effort to explain to you the fundamental principle of ethics in photography, although your prejudices make understanding less than likely. First, you must accept, confess, that enlightened self-knowledge is behind all creative arts, especially photography. Second, that this quest is difficult, earnest and takes a great deal of time and effort. Third, it is focused on the subject matter (whether still lifes or starving refugees). Fourth, the more you know about the subject, the more you know about self, the more you know about the subject, the more ... and so on, in an endless symbiotic feeding process between photographer and reality. Fifth, and most important, when this process of feedback is operating as it should, it is impossible to "exploit" the subject because that means simultaneously exploiting self, which causes the process to self-destruct. On the other hand, when photographer and subject are in synchronous vibration, then issues of ethics and morality become irrelevant. There are no rules, but there are responsibilities, heavier ones than you can even imagine. Because self-interest is not different from but the same as subject-interest. And if you

don't understand that, then you have not understood anything I have said.

Then I am in good company. My guess is that most of the best-known photographers would not understand or agree with you.

That's fine. "Best-known" has little to do with "best." It is difficult, if not impossible, to make fame a goal and pursue self-knowledge at the same time. I pity those who squander their lives in the search of fame – such a piddling, inconsequential notion. Let's face it, fame in photography means your name is recognized by 5,000 people world wide. Tops. In a population of 2.5 billion that's such a tiny percentage it's ridiculous to contemplate. The "best" photographers pursue a higher, nobler, goal, and if fame happens to intersect with their lives, serendipitously, then so be it.

I cannot equate the person who is talking now with the one who began this discussion.

That's because talk is cheap and, like any shoddy goods, quickly disintegrates. You want to teach your readers about ethics and morality? Then tell them to stop reading and thinking about them and get off their butts and shoot more pictures. The problems are not in your head but in your acts – and it is in your pictures that you *know* the right from the wrong. For you. For no one else. What I will not tolerate is anyone telling me The Answer.

So any discussion on these issues becomes meaningless for other photographers …

I think there might be hope for you, yet.

Flash in the pan

EXPLOSION OF THE HINDENBURG

Some of the Individuals and Issues Behind
"The Most Famous News Photograph Ever Taken"

'*Explosion of the Hindenburg, Lakehurst, N.J., 1937*', has often been referred to as the most famous news photograph ever taken.

Hyperbole aside, there is no doubt that it is one of the most famous news photographs in the history of a field renowned for sensational images.

It has even entered the pantheon of Important Pictures (if not Art) by being included in the *History of Photography* textbook[1], used as the medium's foundation for students of photography throughout the world. I doubt if there is a photographer, active in any area of the medium, who is not aware of this image, primarily because of its inclusion in Newhall's text.

But the '*Explosion of the Hindenburg*' is not only a photographer's photograph. It is indelibly etched in the minds of every individual who is at all familiar with 20th century events through the printed media.

As confirmation of this assertion, it was significant that the Hindenburg disaster was often brought to mind by print and television journalists on the recent occasion of a similarly spectacular tragedy: the explosion of the space-shuttle Challenger in January 1986.[2] Many commentators, attempting to describe the explosion, searched for an event of similar visual shock from the recent past, and all found a striking parallel in the Hindenburg disaster image of almost 50 years previously.

One commentator, however, made a slight, but significant, slip. In describing the 'live' images of the disintegrating Challenger being fed into millions of homes, he recalled the evening in 1937 when "the nation watched in horror as the Hindenburg exploded."[3]

The nation did no such thing.

In a pre-television age, the nation listened to the words of radio announcer Herb Morrison, as his voice, racked with emotion, vividly described the scene:

Oh, it's flashing, it's flashing terribly. It's bursting into flames and falling on the mooring mast. Oh, this is one of the worst catastrophes – the flames are leaping 400, 500 feet into the sky. It's a terrific crash, ladies and gentlemen, the smoke and the flames. And now it's crashing to the ground, not quite at the mooring mast. Oh, the humanity!

It was these words which the image, published in the next morning's newspapers, brought to life and made up-close and real. The potent combination of words and image, sound and sight, gave the Hindenburg photograph a special, unique power and propelled it even deeper into the minds of that and subsequent generations. Therefore, it is understandable that the commentator would substitute 'watched' for 'listened' because the still photograph of the crashing, fiery Hindenburg was so clearly etched into his mind. And, more significantly, he could assume that practically all his readers would share the same visual memory.

The 'Explosion of the Hindenburg' had become an icon for failed technology coupled with human tragedy.[4]

The Hindenburg[5] was a self-propelled, steerable (dirigible) balloon of fabric over a rigid frame. Lift was provided by hydrogen gas, which is more buoyant than non-inflammable helium. It was an enormous craft, 803 feet in length and 137 feet in diameter. There was nothing unusual or experimental about its arrival in Lakehurst, New Jersey, on the evening of 6 May 1937. It had already made 36 previous crossings of the Atlantic with commercial passengers. This particular arrival was routine.

The airship approached its mooring mask around 7:20 pm and daylight was rapidly fading. There was some urgency on the part of the ground crew because an electrical storm was on its way, but the craft was being particularly truculent and ponderous to maneuver. Suddenly a finger of flame appeared and within seconds the Hindenburg exploded into a mass of flames. Passengers and crew were leaping from the gondola in an attempt to escape the heat, risking a bone-crushing death to being burned alive. Forty-seven seconds from the first spark the Hindenburg was a smoldering hulk on the ground.

Of the ninety-seven people aboard the airship, thirty-six died, including its commander, Captain Ernst Lehmann.[6] The inevitable question

which remains to be answered is: Who was the photographer who made this famous picture? For reasons which will quickly become apparent, this question does not have a simple answer.

The credit line for the Hindenburg image in Newhall's textbook includes the name of the author: Sam Shere. Shere's name, therefore, has entered the ranks of the 'greats' in photographic history, because Newhall's book is the single most influential book in the medium. Significantly, no details of Sam Shere, nor even his name, are mentioned in the copy which accompanies the image. Shere's fame, at least among photographers, rests solely on the edge of a single image. Few photographers or historians, if any, could describe a single other picture by this news photographer which he took during a professional career of more than thirty years.

The fact may or may not be of importance, depending on the reader's philosophical attitudes toward the medium of photography. However, it does raise an intriguing issue in the field of photography in general: if its images can be so memorable without any interest in or knowledge of the author then perhaps the cult of personality fostered by academia is misplaced. Individuality of expression, the stress on authorship, the emphasis on a pantheon of master-photographers might all be irrelevant. But that is a topic for a separate discussion. Its only relevance in this context is to widen the issue of authorship when referring to the '*Explosion of the Hindenburg*'.

The fact remains that the Hindenburg image recalled by any individual might not have been taken by Sam Shere.

Waiting for the Hindenburg to arrive at its mooring mast at Lakehurst, New Jersey, were about twenty-two still and newsreel cameramen. Practically all of them took pictures of the disaster. Nearly all of the still photographs are practically identical to each other; certainly it would be impossible to assess authorship from the intrinsic nature of the images.

Merely as a few examples, we can name several photographers whose pictures of the Hindenburg crash are as similar to Shere's as two peas in a pod: Charles Hoff of *The New York Daily News;* Gus Pasquarella of the *Philadelphia Bulletin;* Bill Springfield of Acme-NEA; Jack Snyder of the

Philadelphia Record. Then there was Murray Becker, of Associated Press, whose picture of the disaster was selected for publication in *Great News Photos.*[7]

In fact there was almost a surfeit of pictures, by so many photographers, of the Hindenburg crash; perhaps never before had a disaster been so thoroughly documented by the camera. The next morning, the New York newspapers were full of the images; the *World-Telegram* carried no less than twenty-one pictures of the flaming Hindenburg and its survivors. The *New York Post* ran the photographs over seven papers, the *Daily Mirror,* nine. The story, and the pictures, appeared in newspapers everywhere.

The New York *Sunday Mirror* even ran full color shots in its 23 May issue, taken by Gerry Sheedy on 35 mm Kodachrome.

Any one of these photographers might have taken the image of the Hindenburg explosion which is so clearly etched in any viewer's mind. More likely, our memory is an amalgam of several pictures by different photographers seen over the years in different circumstances.

Postscript: Sam Shere

Born Samuel Shereshewsky, in Minsk, Russia, c. 1904, he was brought to America by his orthodox Jewish parents and grew up in the Lower East Side of New York City. His father was a hat maker, who wanted his son to be a doctor. Unfortunately, young Samuel could only tolerate school until the seventh grade.

His first job was carrying a tripod for Pathe News cameramen, at a wage of a dollar a day, plus lunch. After following the cameramen to five-alarm fires, naval yards, and parades, he was settled in his career; he wanted to be a news photographer.

Resigned to young Sam's choice of a profession, his father bought him a 4 x 5 inch Speed Graphic, the standard equipment for a newspaper photographer at the end of World War I (1918). Within a year, Sam had sold his first photograph: a picture of a young girl walking across the Brooklyn

Bridge to Manhattan during a New York snowstorm. The New York *Illustrated Daily News* bought the picture for $7.00.

At this time, however, Sam's interest in photography was in conflict with his even greater interest in going to sea. He signed on as a mess-boy with oil tankers plying between New Jersey and California via the Panama Canal. Even though he spent most of his time on board ship for the next 10 years he quickly found that life at sea was not incompatible with professional photography. He soon had an on-ship darkroom and managed to free-lance during stays in port.

One of these stays lasted for a year, in 1923, when Sam Shere (the name had been abbreviated the previous year) became a photographer for the New York *Evening Graphic* for $50.00 per week. But he was soon missing the smell of the sea, and signed aboard the *S. S. George Washington* as ship's photographer. After one transatlantic crossing, he visited Germany and bought one of the new Leica 35 mm cameras, for $42.00 "and spent the next few years on the other end of ridicule, enduring sarcastic remarks and innuendoes from American news photographers who regarded the Leica as a 'toy'." In spite of the constant ribbing Sam Shere persisted in carrying the Leica everywhere, along with the Speed Graphic, and is now credited with pioneering the use of the discreet 35 mm camera in American news photography.

In 1926 Sam Shere became ship's photographer for the *S. S. Leviathan* (flagship of the United States Line). He made good money for those days, earning $300-400 per round trip across the Atlantic, by selling pictures to the passengers as momentos of the voyage, public relations shots for the shipping line, portraits of notable passengers, and scenics of icebergs and storms. Altogether Shere made 126 crossings of the Atlantic on the *Leviathan*. While disembarked in Europe, waiting for the return voyage, he began free-lance work for the prestigious International News Photo, a part of the William Randolph Hearst publishing empire.

In 1934 Sam Shere left the sea to take a full-time position with I. N. P. It was also the year that Shere's persistence with the Leica led to a celebrated scoop. During the first arraignment of Bruno Richard Hauptmann, a suspect in the Lindberg kidnapping case, Shere smuggled his small

camera into the courtroom and, unnoticed, shot exclusive pictures of the proceedings. The Leica was also used the following year for a major story on the inside of Sing Sing prison. Shere claimed that the series would have been a total failure if it had not been for the speed, ease and silence of the miniature camera. "(It) gave me mobility and did not attract much attention from the inmates. I was able to film, for the first time, candid shots of the prison's rock pile, fire department, flag-making shop, a cell block, the prison parade, the warden's office, the execution chamber and adjacent autopsy rooms ... My 'toy' was gaining its place in news photography through these series."

By 1937, the date of the Hindenburg's explosion, Sam Shere had paid his dues as a news photographer. He was not only in the right place at the right time, but also he was 'primed' to take picture advantage of every situation, such as the Hindenburg's arrival.

Ironically, Sam Shere was reluctant to take the assignment, which was considered a routine one. He had been assigned by his editor at I.N.P. to get some good "society type" shots of the celebrities leaving the airship. Shere recalled: "I had come to think of myself as a 'hard news' photographer, and sort of resented the assignment. I just wanted to get my pictures and get out of there."[8] After waiting for over three hours in drizzling rain, the airship came into view through the evening murk. Suddenly the dirigible exploded. Shere said "I had two shots in my big Speed Graphic, but I didn't even have time to get it up to my eye. I literally 'shot' from the hip – it was over so fast there was nothing else to do." Out of 4 x 5 film, Shere switched to his Leica and began taking shots of the passengers and crew members fleeing the wreckage. "Only one of these pictures, they were so ghastly, so graphic, was ever used ..."[9]

Asked to comment on the significance, and fame, of his photograph, Shere replied: "Many photographers got similar shots. I guess I was just lucky to be in the right place at the right time. I don't really think it my most singular feat."[10]

After 1937, Shere's career as a news photographer was extraordinarily varied. A mere list of his assignments would occupy too many pages. A few highlights include: a story on the return of the Wrong-Way Corrigan

using carrier pigeons to deliver negatives from the *S. S. Manhattan* to New York (1938); photographing the Duke of Windsor, who had abdicated his throne, in the Bahamas (1940); an Atlantic Air Patrol which was cited as the most outstanding news event of the year (1941); invasion of Sicily (1942); several stories for *Life* beginning more than a decade of work for this magazine (1943); Lepke execution and Dewey campaign (1944); VE Day reaction and Pearl Harbor investigation (1945); death of Al Capone (1947); construction of the *S. S. United States* (1948); and so on.[11]

Same Shere shot his last assignment in Ireland at the age of 75. He died in poverty in government housing on 8 July 1982.

References and Footnotes

1. Beaumont Newhall, *The History of Photography*, 5th edition, N.Y., 1982 p. 257.
2. For example: T. A. Heppenheimer, "Time to call the shuttle obsolete," *Manchester Guardian Weekly*, 9 February 1986, p. 7. The first two paragraphs of this article recount the story of the Hindenburg crash.
3. Michael Collins, "After the Challenger Disaster", *The Washington Post*.
4. Heppenheimer wrote: "The Hindenburg exposed the flaws in the dirigible as a passenger carrier, showing it to be an obsolete technology that could not compete with its rival, the airplane. The Challenger disaster, in turn, will point to the Shuttle as a technology that is not only obsolete but also irrelevant."
5. The Hindenburg was named after Paul von Hindenburg (1847–1937), a field-marshall and president of Germany from 1925. He defeated Adolf Hitler in the presidential elections of 1932 but, in January 1933, through political intrigues, was persuaded to appoint Hitler as chancellor.
6. The Hindenburg was owned and operated as a transatlantic passenger service by the German Zeppelin Transport Company.
7. *Great News Photos and the Stories Behind Them*, by John Faber, Dover Publications, Inc., New York, number 31.
8. Interview with Sam Shere, by Joanne Kash, *Art Voices/South*, November/December, 1980, p. 41–42.
9. Ibid.
10. Ibid.
11. An extensive chronology is included in *On Assignment: Photographs by Sam Shere*, Museum of Fine Arts, St. Petersburg, Florida, 1978.

" Fuck Art; Let's Dance " —bumper sticker

CONFESSIONS OF AN ARTISAN

An Open Letter ...

From a reader's letter:

I am a young photographer studying for my BFA at a university. Although I have enjoyed several of your articles in the past, I am puzzled by a tone of ambivalence whenever you mention Fine Art photography. You do seem to disparage the whole idea. At last, photography is accepted by the major museums as an important contemporary art, something which the medium has wanted for a long time. Surely this is a cause for celebration ...

> *Dana Adams*

Dear Dana,

Thank you for your kind invitation to the celebration party. I know it must give you great pleasure that the battle for photography's acceptance as a fine-art is now won. But I fear my presence would hamper your rejoicing. Do not misunderstand. I do agree that, this time, photography has been legitimized by the Artists. It is true that there were successful skirmishes in the past: by Rejlander in 1857, by Emerson in the 1800s, by The Linked Ring Brotherhood in 1892, by Stieglitz in 1902 – and subsequent dates throughout his career – and by many others in the succeeding years. Battles have been won, and the war is now over. It seems fairly obvious that only in the past few years has the medium's manifesto been accepted by the Fine Arts side. This is not the place to list the final skirmishes, of which you are well aware. Apart from these specific evidences of photography's acceptance by fine art museums, gal-

leries and journals, there is a *mood* of acceptance among artists – the zeitgeist smiles.

I am happy that you are now an Artist, if that is what you want. Personally, I am not too sure I am willing to pay the price of membership into such an elitist club. Now that we have been offered membership I have been looking more carefully at the articles of association and the regulations of behavior. I am sorry if my absence from your celebrations seems churlish, and even disrespectful to the medium's leaders who have fought so valiantly for such a day, but I want to study more closely the fine print in the Artist's contract. Meanwhile I would like to share with you a few thoughts on the subject that are causing my doubts.

The first thing that springs to mind is the membership fee. I know, it is a rule of life that every act is accompanied by a price-tag. The universe does not provide free lunches. But the cost is sometimes too steep to warrant payment or, at least, is cause for hesitation. And the acceptance of photography into the art establishment (and academia) is no exception.

The benefits of capitalized (in both senses of the word) Fine Art photography are evident: increased awareness of the medium by our culture; improved social status; a growing support system of dealers, collectors, publishers, galleries, museums, grants and awards; entrenched university patronage with its singular (if nepotistic) network of promotion; and easier access to a plethora of images from all over the world through publications and exhibitions, and so on.

But the entry fee to this carnival is pretty steep because we can never be sure if the attraction of the side-shows is due to marketing or genuine merit. And while we are seduced by the hoop-la we have distanced ourselves from the rest of the medium (and the culture). We have entered a world of sharks, hustlers, prostitutes, con-men and illusionists. It is difficult to retain a firm footing when being jostled by pick pockets or a sense of reality when being enticed by a cacophony of exaggerated claims.

Frankly I hanker for a simpler, clearer and, yes, more peaceful life than that. And I speak as someone who, twenty years ago, fought hard for photography's acceptance by the art establishment – and paid a heavy price for it, and would have been willing to pay more.

134

I now wonder if I wasted my time, energy and money. Then, I felt like I belonged to a small but committed international community of truly caring photographers. I was inside, owning the medium. Now, I feel like an outsider. There's a party going on to which I have not been invited but out of pique I press my nose against a window. What I see inside seems, well, so decadent (such an old-fashioned word but I cannot think of a better one) that I'm both fascinated and repelled simultaneously.

I realize, Dana, that you are probably thinking: he's been left behind by the rush of progress and is now washed up in a backwater while the mainstream swirls past. There's a good deal of truth to that assessment of the situation, I confess. But I would also assert that there are some legitimate, and historically based, justifications for my reluctance to embrace the new and glamorous Photography. Let me try and explain why the words Fine Art give me cause for concern.

Although he was not the sole instigator of the ideas, I expect you will agree that Charles Baudelaire formulated the battle plan of the Fine Arts. In 1858, he wrote:

As the photographic industry was the refuge of every would-be painter, every painter too ill-endowed or too lazy to complete his studies, this universal infatuation bore not only the mark of a blindness, and imbecility, but had also the air of a vengeance ... I am convinced that the ill-applied developments of photography, like all other purely material developments of progress, have contributed much to the impoverishment of the French artistic genius. The only place for photography is to be the servant of sciences and arts – but the very humble servant, like printing or shorthand, which have neither created nor supplemented literature.

This attack on photography by the Messiah of Art has been used as the gospel of the intelligentsia ever since. Photography never recovered from its repercussions. I repeat Baudelaire's remarks because the interesting point about his diatribe is not its sentiment but an inbuilt assumption. The assumption is this: in any comparison between photography and painting, photography must lose because painting is at the pinnacle of art's pyramid, and there is only room for one medium in such a small, elevated area. You might agree about the absurdity of such a hierarchial

structure, however it does exist and we must deal with it. Which brings us to a more serious assumption that is relatively recent in origin and still very prevalent. No one seems to doubt the appearance of Art at the pinnacle of a societal pyramid. This idea of the Artist at the top of the heap, a special sort of mortal, has produced a cult of art that is strikingly and frighteningly akin to a quasi-religion. God parts the clouds, thrusts down his fingertip towards a specially favored man, who lifts his hand in union – a bolt of 'inspiration', 'divine creation', 'a crucial concept', flashes between fingertips.

This image might be an exaggeration but you will not deny it has an element of truth. I have always wondered how the artist achieved this special status. It was history's most successful public-relations campaign. There was a time when another word was applied to the painter: artisan. It looks similar to 'artist' but what a different connotation. Interestingly enough the *painters* were not considered fine artists during the Renaissance. All those who worked with their hands, men of the Mechanical Arts, amongst them painters and sculptors, were simply regarded as 'workmen'. The word 'artist' was reserved for a member of a university faculty educated in the Liberal Arts (in 16th century France it was also used for certain chemical operations). In the Medieval and Renaissance periods, the arts included grammar, rhetoric, dialectic, arithmetic, geometry, astronomy and music. Of these favored few, only music still occupies a place in the contemporary arts. It was natural that the painters were upset at the categorization; they wanted a place in the more prestigious 'artist' group. Eventually they achieved it, but it is not until the late 18th century that the word 'artist' gained its modern definition, and it has grown in intensity and specificity ever since, particularly since the latter half of the 19th century. Undoubtedly, this acceleration of the artist into a special, almost occult, societal role was spurred by photography's competition in the mid-19th century. Interestingly, safely inside the Fine Arts portal, painting used the same arguments against photography that had been leveled against it (painting) during its attempts to gain acceptance as Art. Also of interest, is that once the coockoo of painting had been hatched in the arts nest, it proceeded to kick out the venerable

(legitimate?) eggs of rhetoric and dialectic. Now that photography is a Fine Art it is behaving in the same obnoxious manner.

From a workman's occupation, art has become a special-beings vocation. Becoming an artist is now akin to being a priest or dictator. You doubt it? Read again Hitler's efforts to become an artist in *Mein Kampf*. In an article published in 1938, titled "My Brother Hitler", Thomas Mann recognized in Hitler "...a kinship ... a brother who possessed, whether one likes it or not ... a kind of artistic vocation." Art as religion is also evident from the critics who frequently borrow their vocabulary from the traditional religions, as you must have noticed. From artisan, to artist, to authoritarian has been a logical progression – and one with warnings to photography which seems bent on the same metamorphosis.

It is refreshing to read the 19th century photographic journals in which there was no dichotomy between photography for personal pleasure, art photography for the appreciation of the maker's peers, or commercial photography for sale to the public. An understanding of this remarkable coalition of intents is important in any appraisal of photography in the Victorian age. There is usually such an unbridgeable gulf between fine-art and utilitarian photography in our own age that all too often critics of mid-19th century work either assume the documentary photographer was disinterested in the notion of his work as 'fine art', or insist on giving it a label of art, without considering its utilitarian function. This is understandable, from a contemporary stance, if dishonest. The 19th century photographer viewed his photographs as useful objects and fine art pieces simultaneously; one did not preclude the other. He was artisan *and* artist.

Viewers and critics understood and shared this attitude, not in any sense from a conceptual or philosophical stance. The duality of function was assumed. I find it intriguing that much 19th century work is almost impossible to attribute to a specific photographer. So many negatives were exchanged, bought from other photographer's stocks, commissioned from agreeable professionals, and perhaps issued under the name of the distributor rather than the instigating photographer, that the image, not its maker, is invariably, if involuntarily, glorified. A commercial convenience triumphed over personal pride.

137

I am sure you will agree that the contemporary photographer is easily seduced, even obsessed, by the love of Art, which emphasizes personal glorification at the expense of artisan functionalism. The logical conclusion is a hierarchial structure even within the photographic community – fine artist at the apex of the pyramid, artisans at the base. In such an atmosphere festers neurotic insecurity and false pride, as well as an alienation from the medium's intrinsic characteristics that have made it the most relevant social art of our age. I view with concern, the empty genuflections associated with Art's blessing.

Ingmar Bergman tells a fine story, worth repeating here, of how the cathedral of Chartres was struck by lightning and burned to the ground. Then thousands of people came from all points of the compass and together they began to rebuild the cathedral on its old site. They worked for years until the building was completed – carpenters, stonemasons, laborers, artists, clowns, priests, noblemen and peasants. But they all remained anonymous and no one knows to this day who built the cathedral of Chartres. Bergman concludes:

> In former days the artist remained unknown and his work was to the glory of God. He lived and died without being more or less important than other artisans ... The ability to create was a gift. In such a world flourished invulnerable assurance and natural humility ... Thus if I am asked what I would like the general purpose of my films to be, I would reply that I want to be one of the artists in the cathedral on the great plain. I want to make a dragon's head, an angel, a devil – or perhaps a saint – out of stone. It does not matter which; it is the sense of satisfaction that counts. Regardless of whether I believe or not, whether I am a Christian or not, I would play my part in the collective building of the cathedral.

What an honest and beautiful sentiment. Photographers *have* felt motivated by this concept; but I fear it is fast fading. Art is in opposition to humility. I affirm my belief that the bulk of modern photography, even the best of it, is not art, with its dubious connotations. It is made by artisans, not artists. *But this in no way implies inferiority.* Photography has been, is, can still be, something culturally, socially, historically, more significant than Art.

138

If pushed, I would go even further: I have never seen an exhibition of modern painting which could hold up a candle to the best of contemporary photography. So don't get me wrong. It is not photography which I disparage but the self-limiting, heavy and unwieldy baggage dragged behind the medium as soon as the term Fine Art is attached to it.

I was most interested to read that Jean Gimpel, son of the renowned art-dealer Rene Gempel, has called for a revision of our traditional classification of the arts:

> It is surely time today for us to revise our traditional classifications of the arts or Fine Arts; to exclude some and to admit new ones; to revolutionize the arts, after a lapse of several centuries, in the manner of (the) sixteenth-century.
>
> Certain of the arts which had a function or a role to play in pre-industrial society are no longer suited to our age. These arts or techniques of expression cannot match the scale of our modern world. One might perhaps imagine the Darwinian theory of natural selection being applied to the arts. The Fine Arts which no longer fulfil their original functions, and which, for this reason, are becoming degenerate, should disappear like prehistoric animals. Unhappily they survive like wisdom teeth, serving no useful purpose and causing suffering. It is time the Fine Arts made way for younger and more democratic art forms.
>
> In the first place, painting and sculpture must be ruthlessly excluded from the sanctuary of the arts, just as in the sixteenth and seventeenth centuries they drove out the venerable Liberal Arts. The same is also true of ballet, opera and the theatre.
>
> The visual arts we will introduce in their place are photography, cinema and television . . .

I have no idea whether or not Gimpel was merely engaging in hyperbole or was seriously advocating the notion. But it is an interesting thought to ponder. More interesting, in my opinion, is to recognize the futility of categorizing media and disciplines into any hierarchial structures. Let us, for example, recognize the similarities, not the differences, between creativity in the arts and the eureka syndrome of the scientist. Let us recognize that we are all artisans, collectively and anonymously building a cathedral that will outlast the individual.

These are a few random thought that will prevent me attending your celebrations on admittance to the Fine Arts. I hope you understand. As Robert Frank so aptly remarked, "Opinion often consists of a kind of criticism. But criticism can come out of love."

Sincerely,

Bill Jay

P. S. On rereading this letter to you I was struck by how cautious, even old-fashioned, it sounds. I take solace in the saying: if you are not a radical in your twenties then you lack intelligence; if you are not conservative in your forties then you lack wisdom. So I toss you the keys to the car, Dana, and urge you to enjoy the party without me. I'm going to have an early night with a good book – and no regrets at not joining you.

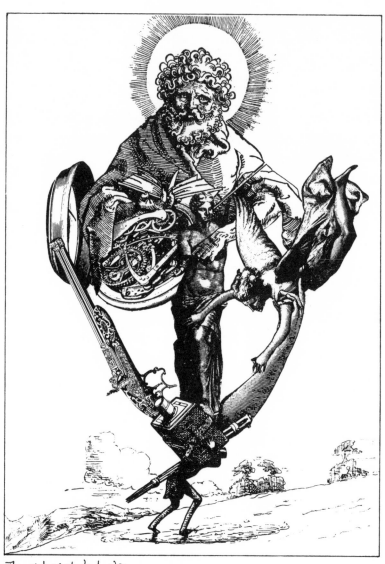

The photographer's burden

E. O. HOPPÉ

A Personal Snapshot

I doubt if there is more than a handful of photographers working today who have ever heard the name Emil Otto Hoppé. Yet he was the undisputed leader of portraiture in Europe between the years 1910 and 1925. To say that someone has a 'household name' has become a cliche, yet in Hoppé's case the phrase is apt. Rarely in the history of photography has a photographer been so famous in his own lifetime among the general public. All photographers revered him; Cecil Beaton simply referred to him as The Master.

In my role of historian I kept encountering his name and my desire to meet this remarkable man began to grow. But it seemed unlikely that Hoppé was still alive. Sure enough, on checking Gernsheim's *History of Photography* I read that he had died in 1967. It was sad that I had missed, by so few years, the possibility of talking to and learning from a living legend.

On 1 October 1971, I was astonished to read, in *The British Journal of Photography*, "My Credo – E. O. Hoppé." Even though this had been written in 1954 there was no suggestion that the author was dead. As a shot in the void, I wrote a letter to Hoppé's last known address. A week later I received a note from Hoppé's daughter – yes, her father was still alive. In my boyhood, a friend and I were walking with our air-rifles when a sparrow flew into the middle of a dense tree. My friend casually lifted his rifle from his hip and fired 'blind' into the foliage. The little bird dropped out, dead. The same feeling of awe struck me on receipt of the letter.

E. O. Hoppé was residing in a small private nursing home in Andover. I telephoned the home and made arrangements with his nurse to visit him as soon as he was well enough to receive a visitor. On 1 May 1972, I drove to Andover and met a frail, craggy-faced old man with sparse

white hair and leonine sideburns. He was constantly in pain and it was even agony for him to move his position in his chair. (He told me that two years previously, during a minor operation, his back had been accidently broken due to careless handling by the staff.)

This was the first of a series of visits that I made to see Mr. Hoppé. It was extremely touching that he valued our meetings so highly, as I did. After each visit, his nurse would telephone or write to me, saying how much Mr. Hoppé enjoyed our talks, and would I please come again soon as he was in much better spirits for several days following our time together. She said that I was his only touch with his past life as a photographer. Understandably, few people knew that he was still alive. Before I arrived, he had prepared notes of his experiences and ideas, written in a shaky black scrawl with pain and painstaking care. It was difficult to decipher their meaning as the words resembled the crazed antics of an ink-covered insect. But I was touched by the effort they cost him.

But it was the personal reminiscences which I valued most highly, delivered in his thick Viennese accent (although he had lived in England practically his whole adult life). His mind, for the age of 94, was active and he would suddenly and excitedly relate an experience perhaps 60 years old, punctuating his voice with winces of pain as he moved in the excitement of telling. My own mind was less attentive. I could not dispense the feeling of strangeness that here I was, faced with a living link to the past, talking to a man who knew, in the flesh, those words on a page – Alvin Langdon Coburn, George Davison, Furley Lewis, Sir Benjamin Stone, Frederick Evans, Horsley Hinton, among photographers: George Bernard Shaw, Henry James, Rudyard Kipling, among the writers; Anna Pavlova, Vaslav Nijinsky, Sergei Diaghiliev, among the dancers – and scores of others, including practically everyone who was anyone in the world of arts, letters, and society. He reminisced about the infamous and the unknown (like his favorite model Eileen) as well as the famous, about his adventures, successes – and failures.

He talked most movingly of his hurt and resentment at the attitude of The Royal Photographic Society. He felt neglected. It was his most fervent wish that before he died he could be awarded the Society's Honorary

Fellowship. He was extremely, and perhaps unreasonably, upset that other, less famous photographers, had been given the honor and that he had been refused so many times. It had become the obsession of an old man. He said: "It is what I would like the most, before I die."

At this point I switched off the tape recorder. Hoppé was crying.

The next day I explained Hoppé's wishes to the officials at The Royal Photographic Society, and how they could make a grand old man so happy at the end of his life. I was informed that the Honorary Fellowship was not awarded for sentimental reasons. I agreed that this was right, but that many photographers had received the honor who had not earned it with such devotion to photography. It was suggested that I should write to the Council about the matter, but little hope was offered, particularly in the light of my own past criticism of aspects of the Society.

Feeling that my own intercession would do little good, I told Cecil Beaton the story, and he immediately agreed to help.

It was very satisfying to learn that due to Beaton's request, The Royal Photographic Society did confer the Honorary Fellowship on E. O. Hoppé just a month or so before he died, early in 1973, at the age of 95.

His last weeks must have been that much happier.

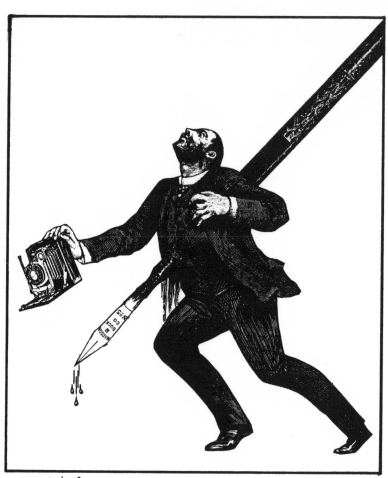

The Critic's Revenge

THE CRITICAL STATE
OF PHOTOGRAPHY

Why so Few Writers on Photography Are Worth Reading

> A book is a mirror; if an ass peers into it,
> you can't expect an apostle to look out.

These are words of wisdom by G. C. Lichtenberg. And we all know the photographic connotations of the word 'mirror', from Oliver Wendel Holmes' description of the daguerreotype as a "mirror with a memory" to John Szarkowski's categorization of photographs into mirrors and windows. Therefore it is natural to substitute the word 'photograph' for 'book' in the quotation and understand, instantly, why there is a paucity of fine critical writing about photography.

I will pause a moment while the indignation caused by my insult to photographers has a chance to subside ...

Let me clarify, and soften, these remarks. An inescapable fact, it seems to me, is that photography does not tend to attract those with the most brilliant *minds,* and criticism is primarily a mental activity. Photographers need, and are often endowed with, many other equally meritorious characteristics. The exact nature of which varies with the type of photography practiced. However, visual acuity, resourcefulness, craftsmanship, human sensitivity and similar traits would be in an unusually high proportion. I am not making value judgements; the ability to perform mental gymnastics is an overrated sport.

If we can abandon, for a while, our natural inclination to defend photography from every seeming slight to its reputation, I believe we would have to acknowledge that most photographers are not mental heavyweights − and we should not expect them to act as if they were. I like photographers, and that is why I enjoy teaching youths who aspire to

enter the field, but it would be dishonest to pretend that students in the medium represent the intellectual elite of the student body.

If it is any consolation to those readers still seething with resentment over these words, I will answer the question: do I think I am any different, someone special, who feels superior to the average photographer/writer? No, I do not. I am well aware that I drifted into photography because I failed at my first, highly academic, choice of careers. My spiritual 'home' was in photography and I have been constantly grateful for that fact.

The bottom line is that photography lacks brilliant critics because the two disciplines demand such totally different temperaments and abilities.

An allied conclusion would be equally insulting but I can see no way around a blunt and provocative remark. Photography is not an intellectual activity and therefore cannot bear the weight of intellectual scrutiny heaped upon it by its academics.

Photography, at its core, does one thing supremely well: it shows us what something looked like under a specific set of circumstances. And that is not very profound. As soon as our talk about photography moves too far away from this central fact it no longer sounds as though it has any connection at all with photography, but more with personal wandering through the labyrinth of the critic's own psyche – and that is about as interesting and relevant as listening to a stranger's dreams.

These, then, are my personal conclusions about the dearth of brilliant critics in photography: first, brilliant minds are not in abundance in the field, and second, even if they were attracted to the medium, there would not be much they could say which would be very relevant. I feel very comfortable with this conclusion; I feel extremely irritated by critics who pretend to profundity by spouting an incomprehensible, irrelevant type of pseudo-intellectual jargon.

I am not implying that there is no place for critics in photography or that the medium would not be a great deal more energized by writers with a wide range of interests in the field. But what would be their function? A perfect answer will be found in *The Dyer's Hand and Other Essays* by W. H. Auden (Random House, New York, 1948). Auden states that a critic can perform one or more of the following services (I paraphrase):

1. Introduce the reader/viewer to works of which he/she is unaware.
2. Convince the reader that he/she has undervalued a photographer's works because they have not been studied carefully enough.
3. Show the relationships between works of different ages and cultures which the reader could never have seen for himself/herself.
4. Provide a 'reading' of a work which increases understanding of it.
5. Throw light upon the process of artistic 'making.'
6. Throw light upon the relation of art to life, to science, economics, ethics, religion, etc.

The first three of these services, says Auden, demand scholarship – but the imparted knowledge *must be of value to others.*

The last three services demand, not superior knowledge, but superior insight, revealed by raising questions which are fresh and important, however strongly one may disagree with the answers.

Yet there are precious few critics in photography who are providing these undemanding services, while our journals are becoming increasingly clogged with photo-gobbledygook. The pages must be filled with *something,* and the result, I presume, is that any old rubbish will do in the absence of intelligible, useful writing.

There are scores, if not hundreds, of intelligent individuals within the field of photography who could, but will not, write for the photographic press. It is worth asking why not. My own sampling of opinions from friends and acquaintances, who should be quite capable of contributing to photographic dialogue through the written word, may be interesting if not definitive. Note that there is no mention of the oft-related cause of the paucity of photographic writers, that photography is a visual medium and that its practitioners do not choose to express themselves in words. If that was true, than what do photographers *talk* about? I have not noticed any reluctance among photographers to lecture about their work! In addition, the fields of music and film are also non-verbal yet both have a critical literature that is infinitely more prolific and astute that photography's.

But that is another topic . . .

My 'survey' of colleagues would indicate that for critics to emerge four factors are necessary, all of which are lacking, to a greater or lesser degree, in photography today.

1. The critic needs an incentive to write. And, naturally enough, that incentive is usually money. One of my colleagues (who is director of a much respected museum program in photography) asserts this is the *only* important factor in why there are so few critics worth reading: if the money was available, the critics would emerge.

 This is not cynicism but an acknowledgement of a fact of life. I believe that A.D. Coleman (one of the few major critics worth reading and capable of being understood) is on record as saying that as a critic his annual gross income was $8,000. That is not only shocking for someone of his stature but also considerable less than the Government's official poverty level.

 'Shocking' as the fact may be, I doubt if there is any individual earning as much in their role of photographic writer, except for those on the staff of *Popular Photography* and other mass consumer publications. I write at least a score of articles for publication annually, and the most I have ever earned from them in a year is about $2,000. And that is only recently; of the 400 plus articles which I have seen in print, the vast majority were freebies, 'for services rendered to the field.' I enjoy writing, otherwise I would not, could not afford to, do it. My writing is subsidized by a university teaching position.

 W.H. Auden was quite clear why he wrote poetry criticism: "because I needed the money." In this sense, photographers are a great deal less fortunate that poets.

 Most magazines in photography have small circulations and operate on grants and fellowships. They cannot afford to pay professional journalism rates. So a closed circle is created and the incentive for writers is diminished.

 Which brings up the next factor influencing the lack of good writing ...

2. The critic needs an audience. And the writer reaches an audience through a publication. Again we have a Catch-22. The large circulation journals which could reward the critic financially either do not publish critical essays with any regularity or they are written by the same, often staff, writer. The small journal, which would be an ideal forum for intelligent essays in photography, cannot afford to pay. Deadlock.

Let us discard the incentive of money. Why not write for the reward of prestige? Or career advancement? We all know that resumé items are particularly valued in academia for the sake of the 'publish or perish' syndrome. However, there are snags. For the photographer, 'publish' means exhibitions of his or her own images; the priority for photographers is, understandably, the making of photographs – not writing about the work of others. Anyway, academia places little value on publications in the photographic press. They are not *scholarly, i. e.,* submissions are not 'juried' by a panel of experts. For this reason my recent application for promotion was not supported by a single one of my (art history) colleagues, even though my publication list was four times that of my dozen colleagues' lists combined.

Again, no reward, no incentive. There are no scholarly journals specifically address to the photographic community in academia.

3. The critic needs something to say. The first rule of journalism is: know what you want to communicate and then state it as clearly, succinctly and forcefully as possible.

Most photographic critics seem determined to reverse the rule: they so obscure the point (if there is one) with such convoluted, unintelligible psycho-babble that the value and pleasure of reading becomes a tedious confusing chore, like wading through knee-high mud in a thick fog.

I have written at length, elsewhere, about this phony intellectualism, and here is not the place for more of the same. Suffice to give one brief, and very typical, example. This is how one photographer described her work: "I juxtapose anticipated with anomalous imagery to create visual analogies. Discrepancy and contrast in scale are emphasized as I investigate perception and memory." At least we are spared

the multi-various 'isms' of aesthetics.

The rule of many writers and critics seems to be that if you frenetically dance around with enough weavings and bobbings you do not make a good target because no reader will know where you stand. Which brings me to the last point.

4. The critic must be willing to take risks. It is interesting that the word 'critical' has two meanings. In this context it refers to exercising judgement or careful evaluation. It also means approaching a state of crisis, which is equally appropriate.

Several of my colleagues stated that the risks of committing opinions outweighed the dubious benefits. The risks were two-fold; first, the reluctance to disagree with or even offend acquaintances in the medium. Second, the fear of litigation. As one who has suffered my fair share of both abuse and threats of litigation for what I have written, I can readily sympathize. Increasingly, personal opinions are dangerous to hold and even more dangerous to express. There was a time, long gone, when opponents from differing viewpoints debated their causes with spirit and passion – and remained good friends. Perhaps it is a mark of intellectual maturity when individuals can separate opinion from personality, when they can love the person and attack the issues. Unfortunately such maturity is dwindling among the ranks of photographers.

In conclusion, there are few critics of photography worth reading because our culture does not value (spiritually or economically) the discipline of writing about photography. And I see no reason why this situation could or should change. It will always be a thankless task. What could and should change is the quality of writing by those who, for a variety of personal reasons, do make contributions to the photographic press.

One way to underline if not accomplish this goal would be for strong editors to reject more manuscripts, even if this necessitated blank pages in the journal – except for the explanation: *This page is empty because the editor refuses to publish any more self-serving, meaningless gibberish under the guise of intellectual criticism.*

152

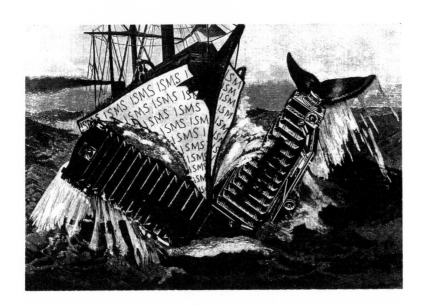

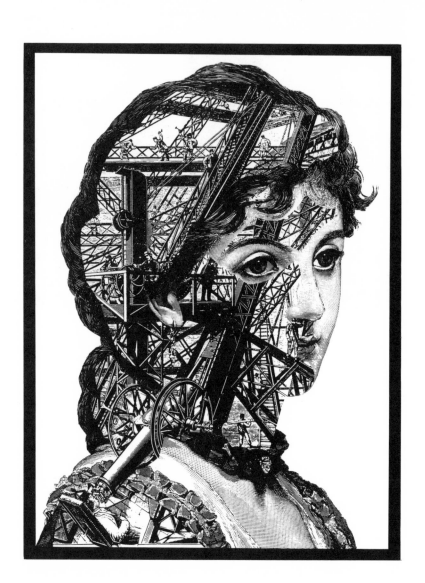

MADONNA MADE ME DO IT

I have been undergoing psychological analysis for the past year in order to discover who I am.

It worked.

I am now able to reveal for the first time in public that, in actuality, I am Madonna.

And that's not all. I have discovered that I am also Napoleon, and Elvis.

I only mention this fact to you because I might say things in the future that will irritate, anger and offend you. Also, I am likely to contradict myself. The point to remember, therefore, is that *none of this will be my fault.* (Elvis and Napoleon argue about everything.)

I now feel wonderfully liberated. Through proper professional therapy, I have discovered a delicious secret: I can now say and do whatever I like because I do not have to take personal responsibility for anything.

In my new-found enlightenment, though, I feel a little embarrassed that so many artists and critics discovered this secret long before me. They have been talking and writing all this time while I was struggling, silly me, to understand what they said, as if they actually took personal responsibility for their remarks, expected them to mean anything, or cared if they were true or not.

Now, of course, I know better. It is gratifying to find out that artists and critics invent their nonsensical sayings because they are nice people. And if they are asked a dumb question, or do not know the answer to a good one, they will make the effort to think up a response. So they are not only generous but also nimble of mind. That's to be applauded.

In the past, when I heard an artist talking a load of old codswallop I would inwardly, and outwardly, groan and presume the speaker was en-

dowed with an I. Q. approaching that of a deep-sea sponge. Now, I think: Heh, quick-thinking, old buddy!

Let us see how this works in practice. Here's how you too can be considered a profound thinker and maker of deep images ...

I.
Get a Rap

Copy down a paragraph (any one will do) from a current critical theorist. Memorize it. Then, in front of a mirror, practice a halting, stumbling delivery with screwed-up face until you can recite it as if the words were being laboriously dredged up from deep in your psyche with gut-wrenching sincerity.

Here's a good example, culled from a recent review of an exhibition: The artist was "connecting the illusion of perception with the reality of thought – the inner reality that is beyond perception of the tangible. At this junction the unperceivable self joins with the unperceivable realities ... The unseeable realities become the force of knowing everything and knowing nothing, and knowing reality."

And may the force be with you.

Don't worry if you flub the lines. "The tangible reality that is beyond perception of thought" sounds just as profound and meaningless as "the inner reality that is beyond perception of the tangible." The point is that your delivery must be intense and convincing.

I know, it would sound more sincere if you made up your own verbal rubbish rather than scrounge around in the garbage heaps of critical theory. Fortunately, with a little practice, you too can learn to gibber. Here's how.

List a few buzz words and phrases beloved by the pseudo-photo-thinker. Here are some appropriate examples: contextualize, taxonomy, dialogical ethics, multicultural, signification, metaphysics, rerepresentation, polysemy, semiotic subversions and revisions. I stole (appropriated) these in a few minutes from one issue of a particularly unintelligible pe-

riodical. Now all you have to do is string them into a verbal sausage. Like this:

"Metaphysically, I employ the theory of signification in order to contextualize the polysemy of semiotic subversions and revisions."

Or:

"Subverting semiotics, I metaphorically and metaphysically empower multicultural rerepresentation."

Or:

"I contextualize the taxonomies of dialogical ethics by revisioning and representing the polysemious multiculturalism."

I *know* they do not mean anything. Wake up, there! Their only purpose is to *sound* dense and important.

Now the beauty of these incomprehensible chunks of verbal offal is that they are useful in any circumstances, not only to describe your own image as it is being scrutinized, upside down, by a baffled gallery director, but also for impressing dates. What you do is this: meander around an art gallery and come to a jarring halt (enough to startle your date and capture his or her attention), squint at a particularly hideous piece, scratch your chin thoughtfully, bend at the waist and, without taking your eyes from a blob in the lower left corner, move crab-like to within a few inches, then slowly back up and mutter (loud enough to be heard by all – but as if musing to self. This takes practice.): "An interesting semiotic subversion of multicultural contextualization . . . "

2.

Stick to Banalities

I am well aware that many of you have trouble pronouncing 'aperture' let alone 'polysemy.' There is no point in flubbing a lot of complicated words (their effect is somewhat diminished if some egghead starts correcting you) when there is a simple(minded) alternative.

In this strategy the idea is to say the most trite thing in such a manner that it sounds like the deepest profundity. This is a technique which has

been perfected by fine-art photographers who lecture at academic institutions. In a voice oozing deep sincerity, say: "I'm interested in (pause) Time." Can you manage that? Good. Now try it while pinching the bridge of your nose – to some members of the audience this will indicate that you had to think long and hard to utter such a banality. (To me, it looks as though the speaker is attempting to stifle a sneeze. Still, by all means add it to your repertoire.).

Once you have mastered 'Time' you can try the same sentence but substituting 'Space' or 'Light'.

Another banal sentence which is frequently used for the same purpose of deception is: "I have a profound respect for . . . " Fill in the blank with: Nietzsche/spirituality/God/pre-literate societies/Foucault (or whoever is the thinker-of-the-month).

And so on.

3.
Pollock It

So far you have been required to memorize up to three sentences. That's tough. So here's a strategy for those with brains composed of Brillo pads. Just say, "It works." That's it – no more, no less, in every circumstance, for all images in every medium.

Its effectiveness increases, however, if you practice saying it with multiple emphases, with a nonchalant shrug or eye-bulging ferocity or with an astonished lilt – as if the questioner is obviously a nincompoop if your assessment if not immediately apparent.

This is the Jackson Pollock defense, and the world of contemporary art (especially photography students) owes him an immeasurable debt for these two words. Not that Pollock was much of a thinker – he hated verbal theories. He was a redneck and an alcoholic; he didn't read much, he punched people who offended him, and tended to piss in the fireplace at parties. Use him as your role model.

This is an *approved* tactic. Owen Edwards, an astute critic, once wrote: "The better a photographer is, the more miserable and neurotic he or she seems to become." Well, you see the wisdom (mine) at work: if Edwards is right, then you can train yourself to become a miserable, neurotic human being first, and *then* you will be known as a great photographer, no matter how stupid your pictures.

4.
Create a Diversion

And the most effective means of not answering any question is to say: "I'm glad you asked me that ..." and then ramble on about a childhood event, preferably one including dogs and sex. Of course it's irrelevant! But if you make it long enough and tedious enough no one, least of all the questioner, will remember what you were first asked. Okay, I hear you. Most of you have led sheltered, boring lives. So ask your friends for a dog/sex story – its amazing what hidden aspects of their past you did not know. Whether you want to remain friends with them is your problem.

Okay, so your friends are boring, too. In which case, fake it. There was the time, remember? when you burst in on Aunt Edna, stark naked, playing with her Saint Bernard in a bath of jello ... The rest is up to you. Now embellish the story with a profusion of irrelevancies and trivialities. If anyone seems bored, remind them that you are conducting 'emotional archeology' (a popular concept nowadays).

5.
Be Political

This is another hot topic right now, especially if your diatribe reeks of leftist cant and is uttered with ferocity and indignation. Practice speaking sentences containing a lot of sibilants through pursed lips in order to get

the spittle flying. Strangely, this strategy is particularly effective when talking to arty capitalist nerds in suits and ties. The point here is to intimidate, and you accomplish this most effectively by ranting and by cultivating a wild-eyed manic appearance.

6.
If All Else Fails, Act Dumb

This is the cleverest ploy of all because it plays right into the minds of those who believe the true *persona* of the creative genius is inarticulate insensibility. These people, you must realize, do not *expect* you to be able to hold an intelligent conversation because you are VISUAL. The smart strategy, therefore, is to act as dumb as possible. Give them what they want. If pushed, mutter: "Uh?" or "I dunno." Your *piece-de-resistance* is: "Like, yer know, it just sort'a, yer know, uh ... comes out like ...uh ... like that."

I could go on providing you with effective strategies but why should I? I don't get paid by the word. Usually I don't get paid at all.

You might be wondering, therefore, why I am revealing, for the first time anywhere in print, these secrets of critical thinking. There was, I admit, some internal squabblings about the wisdom of revealing these conclusions to people like you who have not had the benefit of deep psychoanalysis.

Elvis, taking time out from his job as a bag boy at the Piggley Wiggley's in Dubuque, Iowa, was all for maintaining a low profile. Napoleon wanted to send in his army to obliterate all critics. This led to an acrimonious exchange with Elvis calling Napoleon "shorty". Napoleon indignantly insisted he was not short, but merely "vertically challenged." We were getting nowhere, until Madonna sasheyed into the fray and insisted on getting her way, which she usually does. "Let it all hang out," she said. And she did.

ACKNOWLEDGEMENTS

This book is a 'companion-volume' to *Cyanide & Spirits: An Inside-Out View of Early Photography* (also published by Nazraeli Press), an anthology of articles on aspects of 19th century photography.

Occam's Razor: An Outside-In View of Contemporary Photography is an anthology of articles on modern issues in the medium. Most of these articles have been previously published in various journals during the past decade or so. A few of them were originally presented as lectures. It is appropriate that these publications and presentations should be acknowledged:

"Keeping the Photograph at Arm's Length" was written for and presented at a symposium, 'Life/Work', at the San Francisco Art Institute, California, April 1986; "The Thing Itself" was published in *Newsletter*, Daytona Beach Community College, Spring/Summer 1988, reprinted in *Shots* 10, Oregon, October 1988 and in *Zone VI*, Vermont, Number 61, December 1989; "Threshold- The Disturbing Image", was written as the introduction to an exhibition at *Camera Work,* San Francisco, and published in its journal, Spring 1988; "The Naked Truth" appeared in *Shots* 17, September-October 1989; "Diane Arbus: a personal snapshot" must have been published (although I have no record of where or when) because the author Patricia Bosworth had read it and asked to quote my experiences in her biography of Diane Arbus; "Creating a Viable Dialogue Situation" was published in *Ffotoview*, Cardiff, S. Wales, Issue 3, Summer 1982; "Professors and Professionals" first appeared in *Newsletter,* Florida, Spring 1985; "Bill Brandt: A True but Fictional First Encounter" was written as a part of a lecture presented at the San Francisco Museum of Modern Art for the opening of its Bill Brandt retrospective exhibition, November 1987, and it was subsequently published in *Shots* 14, 1989, and in the organ of the Alaska Photographic Center, September 1989; "Some-

thing Fishy" was written on invitation by Robert Heinecken to accompany one of his original images in the limited edition portfolio *Recto/Verso*, 1988; "The Family of Man" was published in *Insight*, Bristol Workshops in Photography, Rhode Island, Number 1, 1989; "Past Perfect" was first published in *The British Journal of Photography*, London, October 1982; "Original (and Reproduction) Thoughts" appeared in *Shots* 11, 1988: "W. Eugene Smith: A Personal Snapshot" also first appeared in *Shots* 33, Summer 1992; "The Ethical Anarchist" was published in *Shots* 32, April 1992; "Explosion of the Hindenburg" was published in *Newsletter*, Florida, Spring/Summer 1989; "Confessions of an Artisan" was published in *Shots* 24, Fall 1990; "E. O. Hoppé: A Personal Snapshot" was published in *The British Journal of Photography*, December 1982, and in *Studies in Visual Communication*, University of Pennsylvania, Vol. 11, No. 2, 1985; "The Critical State of Photography" was first published in *Center Quarterly*, The Catskill Center for Photography, Winter 1985/86 and in *European Photography*, No. 48, Vol. 12, Issue 4, October-December 1991; "Madonna Made Me Do It" appeared in *Shots* 35, Fall 1992.

If I have omitted any publications which should be acknowledged, I apologize. I confess to a laxness in keeping such records – the next article, the one not yet written, is far more engaging than the fate of past ones.

I should also like to take the opportunity of acknowledging my gratitude to Chris Pichler of Nazraeli Press who was primarily responsible for selecting and editing the articles, and for the book's design. It is rare, in my experience, to work with a publisher who is as decisive, conscientious and committed to the end result. Chris has made the publication of *Cyanide & Spirits* and *Occam's Razor* the most satisfying experiences of my publishing career.

Other books by Bill Jay

Views on Nudes
Customs and Faces: Sir Benjamin Stone 1818-1914
Victorian Cameraman: Francis Frith's Views of Rural England 1850-1898
Victorian Candid Camera: Paul Martin 1864-1944
Essays and Photographs: Robert Demarchy 1859-1936
Negative/Positive: A Philosophy of Photography
Light Verse on Victorian Photography
Route 60 (with James Hajicek)
Photographers Photographed
Bernard Shaw on Photography (with Margaret Moore)
Cyanide & Spirits: An Inside-Out View of Early Photography★
The Photographers: Volume 1★

★ also published by Nazraeli Press

A six-legged tripod, or sextipod.